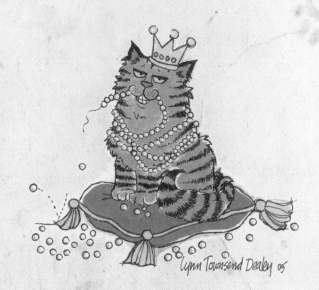

Lynn Townsend Dealey 05

TEXANS

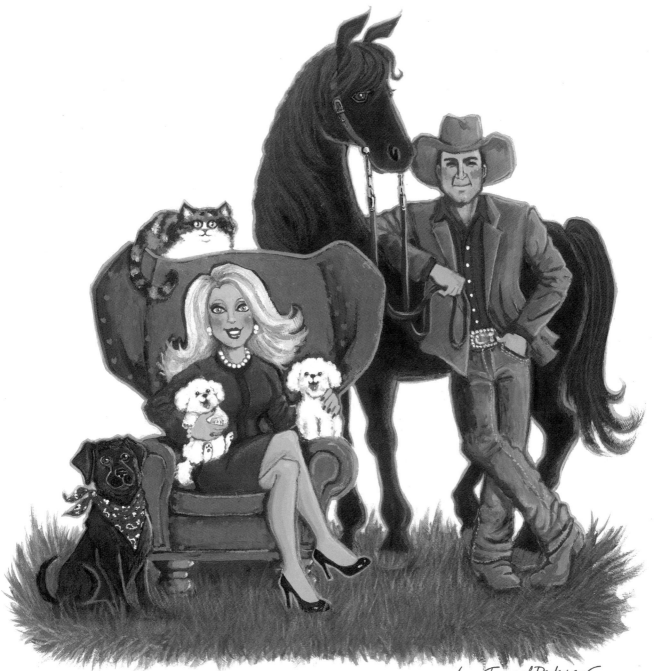

Lynn Townsend Dealey 2005

AND THEIR PETS

Published by

13747 Montfort Drive, Suite 100
Dallas, Texas 75240
972-661-9884
972-661-2743
www.spgsite.com

Publisher: Brian G. Carabet
Designer: Michele Cunningham-Scott

Printed in Malaysia

Distributed by SPCA of Texas
214-6651-9611

PUBLISHER'S DATA

Texans & Their Pets

Library of Congress Control Number: 2005909836

ISBN No. 0-9745747-3-2

First Printing 2006

10 9 8 7 6 5 4 3 2 1

Previous Page:
Original artwork by Lynn Townsend Dealey

This Page: Mary Spencer's belved cat, Ross.

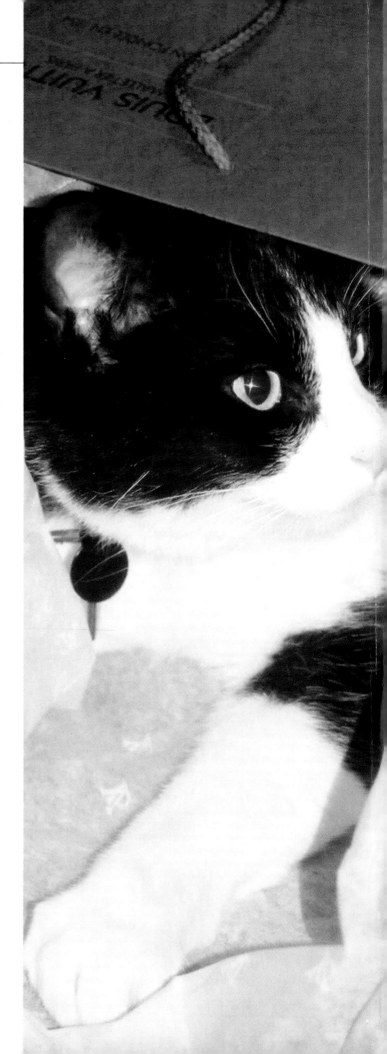

SPECIAL THANKS

Mary Spencer – It was at a separate book launch party several years ago that the idea of Texans and Their Pets was born. Mary, as Chairman of SPCA of Texas, was a great champion for the project as well as the benefit to SPCA and the animals it helps. Thank you Mary, for your guidance and enthusiasm for the book.

Lynn Townsend Dealey – Lynn was also part of the original "idea committee" along with Mary Spencer that developed this book. An accomplished and renowned artist, as well as a super person, Lynn has donated her time to produce the illustrations on the cover and elsewhere in the book. Thank you Lynn, for capturing the heart and soul of the project in your artwork.

Paul Skipworth – Paul originally was going to consult and occasionally shoot photos for the project. As the project evolved, Paul got more and more involved to the point of becoming our exclusive photographer. We were truly fortunate to have a true artist with his pedigree and abilities generating the images you see on the following pages. Thanks Paul, for stepping in when we needed you the most.

Karla Setser – Karla's involvement in the project started as the Assiciate Publisher for the book. When our original writer had unexpected circumstances that forced her to leave the project, Karla stepped in. This is her first literary work for the publisher and we're proud to have her on the team. Thank you Karla, for your never-say-die attitude and unmatched sense of team.

FOREWORD

"Our Pets are the Family that we Choose."

Imagine a world where every adoptable animal could find a home: a home and a parent much like the ones featured in this book. As you read about these lucky creatures, it's obvious that Texans' pets are definitely a part of their families. This special bond between animal and human is extremely strong and these featured Texans, without question, consider their animal companions to be cherished family members.

The idea of a book devoted exclusively to Texans and their Pets originated a few years ago during the throes of events for the *Texas Women* book, when conversations with various Texas women consistently revolved around their pets. When the subject of pets came up, there were more heartwarming animal stories shared by these women than I ever imagined. Later, in conversations with men, the outcome was the same. Texas folks loved to tell stories and to brag about their pets! Even more so than about their kids! It quickly became obvious that in Texas, pet owner's hearts are as big as the state itself!

What could be more fun and memorable than portraying Texans who shared this same passion with their pets? The proceeds from sales of this book will help the SPCA of Texas achieve the goals of being able to place every adoptable animal in a loving home and will help fund a new facility for the SPCA, a warm and welcoming "home away from home," where all homeless creatures will wait for their new families in a pet-enriched, friendly environment. All abused, ill or injured pets will be treated before they are given their second chance at life and a new home. The most important part of this is: All SPCA adoptable animals will get this chance!

I was extremely honored when asked to write the Foreword for this special book. Animal welfare has been my passion throughout my life and the SPCA of Texas is an organization that I have been involved with for more than twenty years. Many of the pets featured in this book came from shelters and had traumatic lives "before" and are finally living the life they deserve. But then again, don't they ALL deserve a loving home and a pampered lifestyle?

We must continue to be the voices for our four-legged friends. They speak to us through a wag of their tails, a smile on their faces and depend on us for their life. Our pets believe in us; they give meaning to our lives and give us a reason to get up in the morning and come home at night. They give us total unconditional love; they ask no questions and pass no criticism. By loving and understanding animals, perhaps we, as humans, can come to understand each other a little better.

Chief Seattle, back in the 1800's in what is now Seattle, Washington, summarized this beautifully. He said: "We are part of the earth, and it is part of us. The perfumed flowers are our sisters, the deer, the horse, the great eagle, these are our brothers. What is man without the beasts? If all the beasts were gone, man would soon die from a great loneliness of spirit. For whatever happens to the beasts, soon happens to man. All things are connected."

Imagine a world where every adoptable animal could find a loving wonderful home, just like the ones in this book. Hopefully, with the awareness and assistance from people like you, this will be possible, hopefully, sooner rather than later. As Louis Armstrong would say, "What a Wonderful World" THAT would be ..."

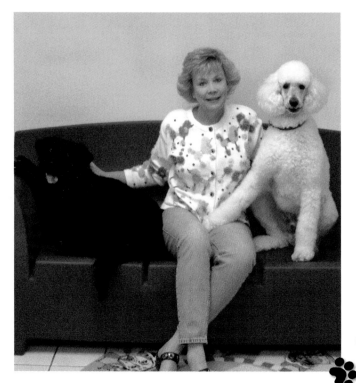

Above: Mary pictured with Libby (black labrador) and Charley (poodle).

TABLE OF CONTENTS ❀

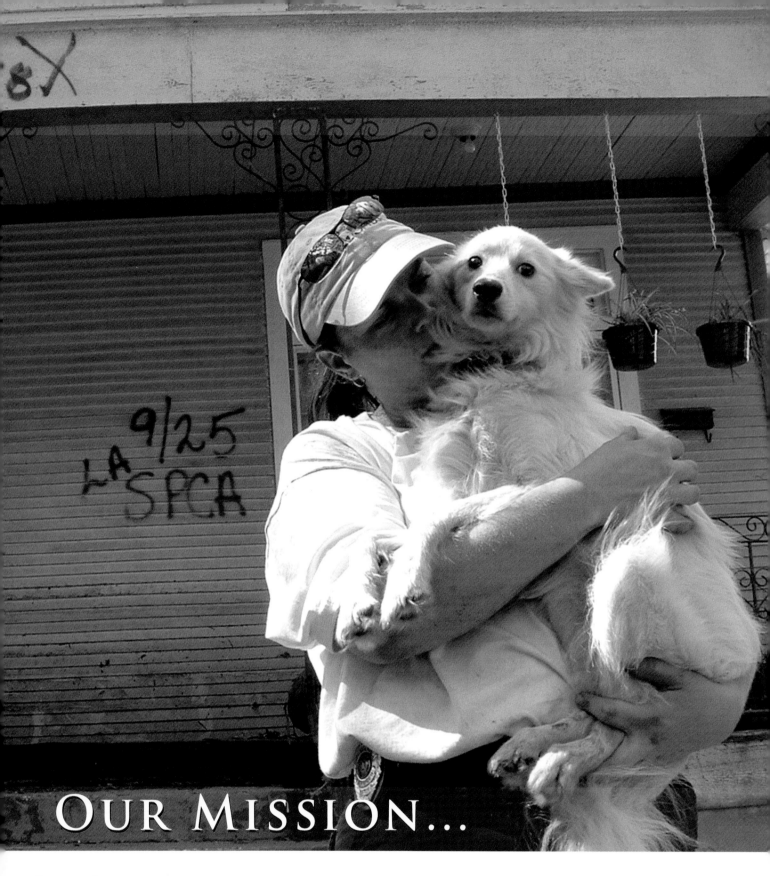

OUR MISSION...

The SPCA of Texas is a charitable organization dedicated to improving the welfare of all animals. The leading animal welfare agency in North Texas, the SPCA features two shelters and two spay/neuter clinics located in Dallas and Collin County. We serve as an active resource center for the North Texas community providing an array of programs and services that bring people and animals together to enrich each others' lives.

ABOUT THE SPCA OF TEXAS

This comprehensive, compassionate animal welfare agency does not receive funds from the city, state or federal government or any other groups such as the ASPCA.

An open door, private, 501(c)(3) nonprofit organization, the SPCA of Texas provides continual public information through all avenues of available media, including live, weekly television spots and radio shows, as well as the quarterly Animal Talk newsletter, 1-888-ANIMALS phone line, and website at www.spca.org. In addition to seeking specific funding for equipment and capital needs, we are always seeking volunteers to help with the animals and work for the animals through data entry, mail fulfillment, carpentry skills, and fundraising.

Responding to the community through private donations since 1938, the SPCA does not place any time limits on animals waiting for adoption.

History of the SPCA of Texas

In December of 1973, the SPCA moved into our current facility located at 362 South Industrial Boulevard in Dallas and is known as the E.M. "Ted" Dealey Animal Care Center. We merged with the Humane Society of Texas of Collin County in 1993, expanding our capabilities within the animal care, rescue and investigations, and veterinary care service areas.

The SPCA of Texas is the only full-service animal care agency in the Dallas/Fort Worth Metroplex, providing not only adoption and foster care programs in two facilities, but also a spay-neuter and medical clinic (the Martin Spay/Neuter Clinic) that was established in 1976, a rescue and investigations service that was formally organized in 1984, educational outreach programs that began in 1989, a second spay/neuter clinic that opened its doors in 1995 in McKinney, and an offsite adoption program that began operations in 1995. In 2002, we opened a new, state-of-the-art animal care center in Collin County known as the Russell H. Perry Animal Care Center and Education Campus.

SPCA of Texas Rescue and Investigations

Investigating reports of animal cruelty is one of the toughest but one of the most vital parts of our mission.

The SPCA maintains a Rescue and Investigations Department with four full-time humane officers who investigate more than 4,000 cases of cruelty each year in Texas of which less than 20, or less than half of one percent, are pursued with civil charges. The balance of the cruelty investigations are resolved through education or other corrective measures. The Rescue and Investigations Department also inspects places where animals are utilized, kept, sold, traded, or bartered to ensure the animals are being cared for properly under Texas law. Receiving an average of 9,500 calls a year from people who have seen or know about cases of animal cruelty, the officers rescue almost 700 animals in distress each year in a variety of Texas counties. The phone calls are often requests for investigation or rescue because the animals don't have water, food, shelter, or care. Other calls often include cruel confinement or abuse concerns.

Most animals investigated or rescued are dogs, cats, horses, and cattle. Humane officers receive on-the-job training and basic police training.

SPCA of Texas Social Service Programs

The SPCA offers a variety of programs that enhance the human experienced through interaction with animals.

These programs include those that educate children, assist people and pets in need, reunite lost pets with their families, counsel people whose pets have passed away and provide for pets that outlive their owners.

The Pet Grief Counseling program is an innovative and dynamic program designed to help those who are grieving the loss of a beloved companion animal. Established and conducted by Dr. Diane Pomerance, certified Grief Recovery Specialist and SPCA volunteer, the SPCA's Pet Grief Counseling program offers comfort, guidance, and support to help facilitate grief recovery.

The Compassion Connection offers animal-assisted activities and therapy for hospitalized children and adults, retirement homes and rehab centers.

The Pet-O-Meals program delivers free pet food for homebound elderly and individuals on disability in Collin County.

Pet Haven provides short-term foster care for pets of families living in domestic violence shelters.

To find out more about the SPCA of Texas, please visit **www.spca.org** or call 1-888-ANIMALS.

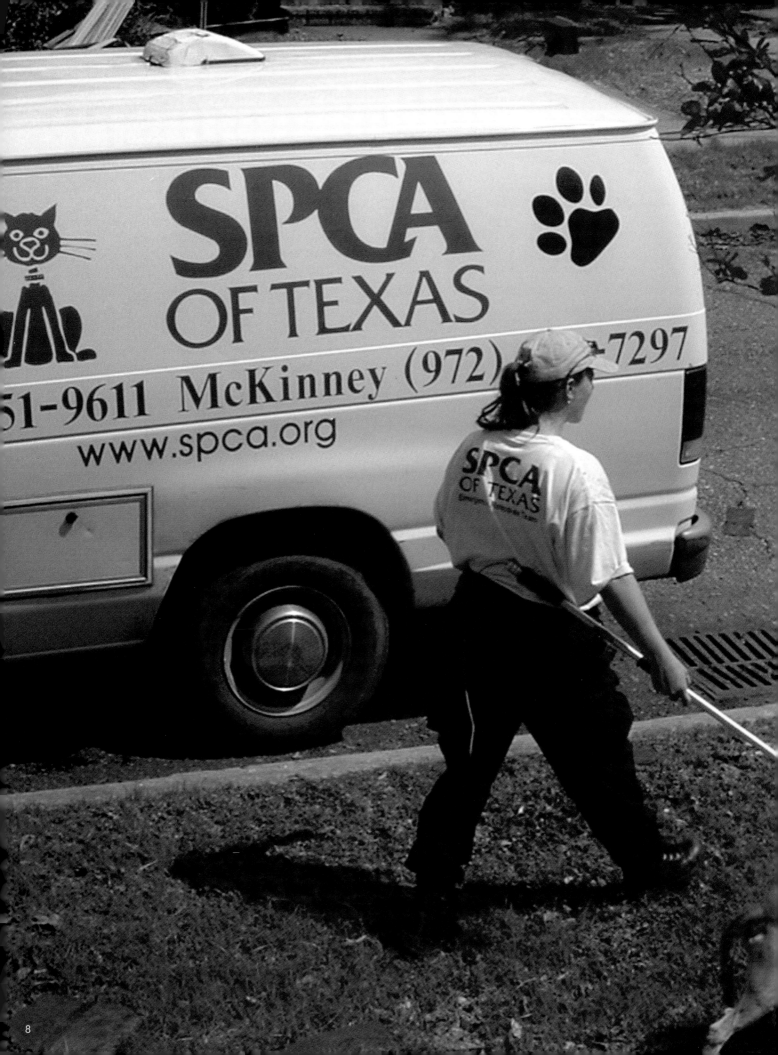

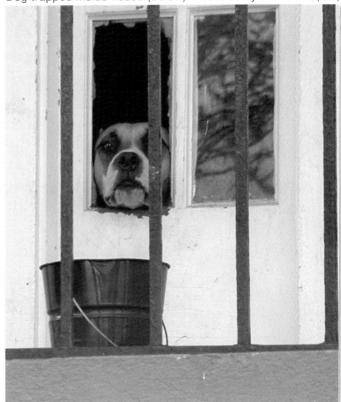

Dog trapped inside house (below) Rescued by the SPCA (left)

SPCA OF TEXAS

Dallas (SPCA Headquarters)
362 S. Industrial Blvd.
Dallas, TX 75207
phone 214.651.9611
fax 214.651.9244

Collin County
8411 F.M. 720
McKinney, TX 75070
phone 972.562.7297
fax 972.562.0018

The Colony
4720 E. Lake Highlands
The Colony, TX 75056
phone 972.625.5545
fax 972.624.2238

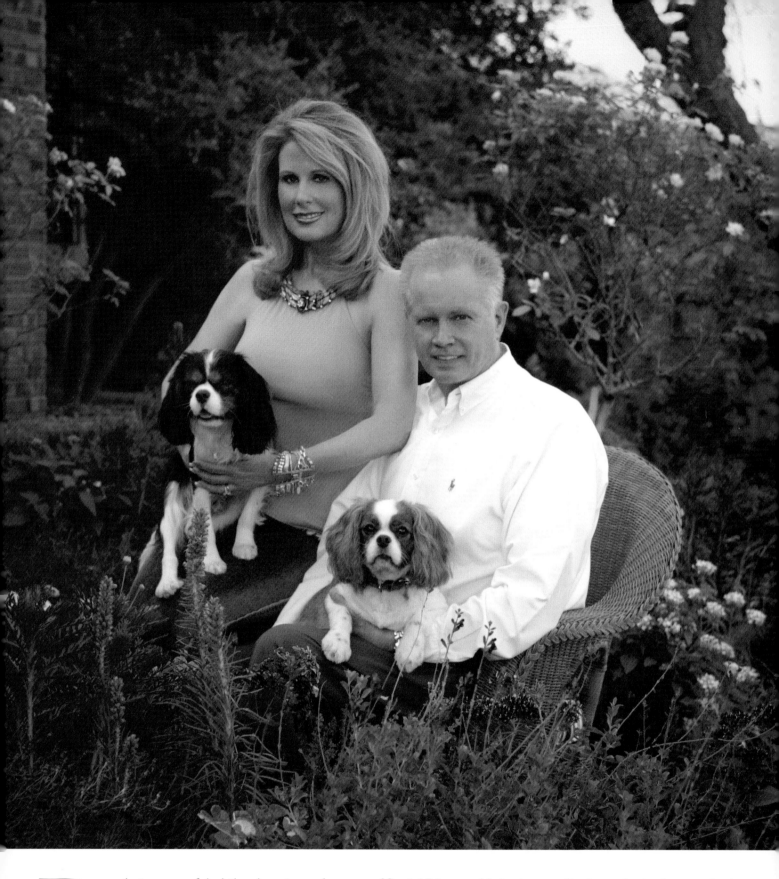

Beverly is a graceful philanthropist and owner of Social Lites and John is a medical oncologist/hematologist and partner of the Arlington Cancer Center. Together they believe in the importance of respecting all of God's creatures, especially animals.

BEVERLY & JOHN ADAMS

Windsor William Adams
& Spencer Churchill Adams

A few years ago, Beverly, John, and daughters Crystal and Ashley adopted seven-week old Hallie Marie, a Blenheim Cavalier King Charles Spaniel. Unfortunately, the puppy passed away at four months due to a congenital disorder. The family was devastated and heartbroken.

After a time of grieving, they decided to contact the breeder about getting another puppy. The breeder was very sympathetic to the situation and invited them to visit the new litter of puppies that were three weeks old. At their first visit, one puppy kept making his way into their laps. Windsor William Adams had plans for them as he was on a mission to steal their hearts. Each subsequent time they went to admire the litter; Windsor would jump into Beverly's arms. He then proceeded to grab her diamond heart necklace with his puppy teeth and would not let go! Windsor was to become an important part of the royal Adams family. About one year ago, Spencer Churchill Adams, a tri-colored Cavalier King Charles Spaniel, also made himself at home with the family.

The dogs names reflect Beverly's fascination with English royalty, customs, and traditions. Throughout history, there have been many fascinating stories about this breed and the roles they played in the lives of the British Monarchy.

Beverly and John's English Tudor-style home in Las Colinas is a haven to their two royal pups and also to Ashley's Chihuahua, Isabelle. Their English Garden features a beautiful statue of St. Francis of Assisi, the Patron Saint of Animals. Stray animals sometimes make their way into the garden; they seem to know that St. Francis is looking after them along with the help of Beverly and John.

St. Francis was born to a wealthy family in Assisi, Italy in 1182. After a carefree youth, an illness led him to renounce the wealth of his family and answer God's call to rebuild the Church. He was canonized in 1228. St. Francis is said to have loved the larks flying about his hilltop town and is remembered each fall in an outdoor ceremony called the "Blessing of Pets." This custom is conducted in remembrance of St. Francis' love for all creatures and his devotion to God's handiwork.

At Franciscan churches, a friar with brown robe and white cord often welcomes each animal with a special prayer. The Blessing of Pets usually goes like this:

Blessed are you, Lord God, maker of living creatures on earth. You called forth fish in the sea, birds in the air and animals on the land. You inspired St. Francis to call all of them his brothers and sisters. We ask you to bless this pet. By the power of your love, enable it to live according to your plan. May we always praise you for all your beauty in creation. Blessed are you, Lord our God, in all your creatures! Amen.

Like St. Francis, Beverly and John believe every creature is important and has a purpose. According to Beverly, "the love given and received from pets draws us more deeply into the larger circle of life, into the wonder of our common relationship to our Creator."

 Q & A

Would you say your pets are spoiled? Very much so! Doggie day care every day while we work, weekly grooming appointments, haute dog cuisine, and dog sitters on the weekends!

Do you dress up your pets? Only in Coach or Swarvoski Crystal collars.

Do you feel your animals have touched your soul/inner being in some way? Yes! It is a blessing to share our lives with our dogs. They have added joy, happiness, comfort and love to our family.

The legacy of Straydog, Inc. tragically begins with the unexpected death of Bill Arnold's wife, Pat. After suffering a brain aneurysm on Saturday, May 31, 2003 and before she lost consciousness, Pat Arnold said these final words to her kennel team members gathered around her, "Take care of my dogs while I'm gone."

BILL ARNOLD

Jack & Jill

Straydog Inc. is a nonprofit no-kill rescue facility, life boat and sanctuary for rescued, homeless, abandoned or abused dogs. It is located in Gun Barrel City, about seventy miles southeast of Dallas. The organization does not compete directly with the SPCA as it serves a different area. The organization is also affectionately dubbed the "Arnold Family's Happy Home for Strays."

Bill said, "We believe that the example of our sacrifices must be publicized to wake people up and make them aware of the necessity to SPAY and NEUTER their dogs and cats so that homeless dog and cat rescue life boats will no longer be necessary." He continued, "We want all stray dogs to be lucky dogs … now!" Bill added, "We love dogs and feel they should all have a fair shake at life. We are greatly troubled and discouraged by irresponsible humans who allow their dogs and cats to procreate wantonly and don't take responsibility for the unplanned offspring. Straydog, supported solely by donations, can never seem to raise enough funds to at least take care of all the homeless who cross our paths."

According to Bill's daughter, Erin Arnold Johnson, "We have numerous dogs waiting to be adopted, just like the SPCA of Texas. We share a lot of the same goals. We take a van load of beautiful dogs that we've nursed to health, vaccinated and neutered to an adoption site every weekend, hoping that the right family will come along and love the animal by giving the doggie a forever home."

A heartwarming story Bill provided is when his late wife Pat heard about a blind dog, Stevie, at a county animal shelter. Pat wrote, "When I went to see this special fellow and walked up to the cage in which he was being kept, the sight of his precious face took my breath away. He sensed that I was there and began swaying his head from side to side until his face touched my fingers and he nuzzled my hand with his furry little head. I brought him home to take care of forever."

Now living in a forever home with Mike and Ann Nicholson, Stevie and his adopted kennel mate and seeing-eye partner, Little Pete, occasionally email Straydog. Stevie wrote, "We want to tell anyone out there thinking about the problems with adopting a blind dog: Our dad says every day it becomes more and more rewarding to be able to give a handicapped puppy a chance at a happy house life."

Rescued in March 2003 as little puppies, Jack and Jill, sweet, white Aussie pups, are also deaf and blind. They enjoy the love and care they get as well as their outings in the big park play yard at Straydog. Both run and play as if they were not handicapped at all.

People like the Arnold Family and organizations like Straydog Inc. help dogs like Stevie, Little Pete, and Jack and Jill to have the life that every dog deserves.

www.straydog.org

Q & A

What is Straydog Inc.? Straydog Inc. is a 501(c)3 non-profit, no-kill rescue facility, life boat and sanctuary for rescued, homeless, abandoned or abused dogs, currently caring for close to 100 dogs and one cat.

What year was Straydog Inc. founded? Straydog Inc. was founded in 1997.

How many dogs are placed in permanent homes each year? Straydog places approximately two dogs per month. We have wonderful volunteers who help us coordinate and doggie-sit during our weekly Dallas-metroplex Adoption Days. We have several inquiries which lead to adoptions off our **www.petfinder.com** link too.

What is Straydog's contact information? Phone (903) 479-3497, Straydog Inc., PO Box 1465, Gun Barrel City, TX 75147. Read the daily Straydog happenings at **www.straydog.org**

The Barajas are huge animal lovers. Their family includes Rod, wife Stacie, sons Andrew, Bryce, Rod, Jr., daughter, Aunalilia, and three dogs:

ROD & STACIE BARAJAS

Lexie, Cheech & Pepe

Lexie, a four-year-old Yellow Labrador, Cheech, a two-year-old tri-colored Bernese Mountain Dog and Pepe, a one-year-old tri-colored Chihuahua.

When asked if his pets are compassionate, Rod said, "All the dogs love attention and are big on cuddling, especially with the kids. My family feels very safe when I am away at games."

The dogs are very loyal, protective, adoring members of the family. Rod said, "When I'm home the dogs are pretty cool around others. But when I'm gone the tables turn and they become protective, even with my teammates. Once my wife was in the car with the dogs and Kevin Mench came up to the car. Lexie was growling and wouldn't even let him come close! She is a big protector of the family."

Rod continued, "The big dogs are also watchful when the kids are outside or in the pool. They seem to watch over them and run to where they are if one of the kids begins to cry."

When asked if the pets are spoiled, Rod smiled, "The kids want to get something every time they see dog toys. They are always explaining to me why the dogs need a new toy … I think I've heard all the excuses by now!" Stacie said the big dogs' favorite treats include bones, rawhide chews, Kong toys filled with peanut butter, Frisbees® and especially any type of ball. Pepe also loves very small balls and squeaky toys.

The pets have a very loving side at home. Rod said, "The dogs' eyes just light up when they see the kids. The big dogs sleep in the kids' rooms and the Chihuahua sleeps in our master bedroom."

Other cute things about the Barajas' pets include: Lexie talks in a muffled breathing way; Cheech, a seventy-five-pound dog, thinks he's a lap dog; and Pepe always cleans the kids with his tongue. Rod said, "I don't know if you'd actually consider that cute, or gross!"

Pepe also enjoys getting dressed up. He has camouflage gear that includes a vest and matching hat. He has a wardrobe of t-shirts with different sayings on them, such as, "Rub my Buddha belly for good luck." The pup also has a puffy scarf with hearts on it that he wears for Valentine's Day.

Rod is very proud of the pooches for helping teach the kids responsibility in regards to feeding, bathing and cleaning up after them.

 Q & A

Would you say your pets are spoiled? Our pets are extremely spoiled! They should be with two adults and four kids loving on them!

Do you dress up your pets? My wife dresses our Chihuahua, Pepe, up. She even has these sunglasses he wears. It's hilarious! He has camouflage gear that includes a vest and matching hat. He has a wardrobe of t-shirts with different sayings on them, such as, "Rub my Buddah belly for good luck."

What touches your heart the most about your pets? How loyal they are and how much they adore the kids.

Do you consider your pets family members? Absolutely! We have four kids (with another one on the way) and three canine kids!

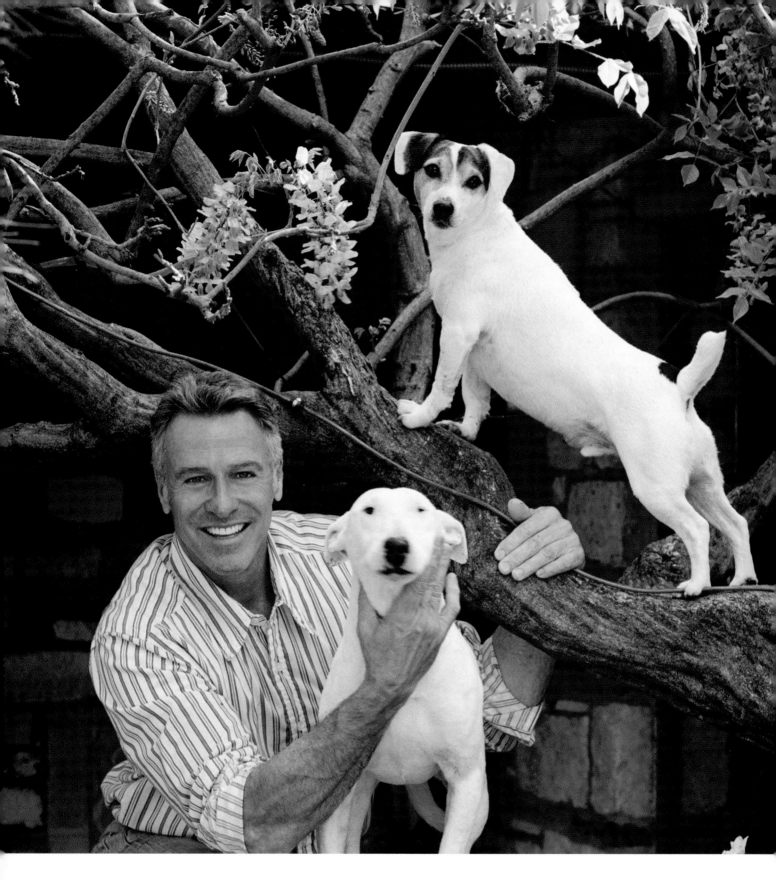

R obert Bellamy's beloved ten-year-old, spunky Jack Russell Terrier, Ryder, can scale a tree as quickly as a cat and has astounding balance; the dog never falls down! Ryder's sidekick, Weasel, is a seven-year-old British Bull Terrier who is small in stature.

ROBERT BELLAMY

Ryder & Weasel

Robert adopted Weasel from Marilyn Sibley's Bull Terrier Rescue Club. Marilyn found Weasel in the rain at a bus stop. Ryder and Weasel are Robert's family and keep patrol over his home and his architectural landscaping office. Both dogs are dedicated hunters and protectors. Ryder gets to join Robert at most job sites and is quite the observer of his surroundings.

Ryder started with nine lives and has since lost three of them. While driving through the desert, Robert fell asleep and unfortunately flipped his car three times. The sun roof was open and Ryder was tossed out but luckily not injured. While visiting his property in Marfa, Texas, Ryder was hunting as usual and survived a rattlesnake bite in his left ear. A little over a year ago, Robert was crossing the street to see his friend Murry and told the staff to keep the door closed. Unfortunately, the mail man arrived and opened the front door. Ryder took off across the street and was hit by a car. Ryder only had a cement scrape, like a burn, and lost some patches of hair permanently, but there was no internal damage.

Depending on the definition of spoiled; Robert's dogs have a great life. They are with people all day long and have an acre-and-a-half to run on at all times. They sneak in bed with Robert and enjoy treats and greenies. When Robert's friend takes Ryder to the dog park, Ryder would rather sit in the back of the car and observe the other dogs playing. He is a snob!

When asked if his dogs are compassionate, Robert said, "Oh yes! Weasel flops in your face and is a love monger. Ryder is more independent. He worried about me and was depressed after the car wreck until I was released from the hospital and arrived at my friend's house who was keeping him."

Continued Robert, "They each have their own personalities and I respect that, and they respect me. I don't try to corral them; I just trust and respect them. Any time I'm low-down, they give me that love that just touches my heart. They'll do anything for me. The moment I come home they are doing circles, and those moments are so sweet. I am their world and they give unqualified love. They are my little white apparitions in the yard."

Some of the cutest things that make Robert laugh are watching Ryder run up a tree or watching him on the prowl. Ryder shows off every time Robert gives client tours; he has a routine way of getting their attention.

Said Robert, "Ryder and I have been through intense periods together, reassuring in some ways and he is so intrepid that I know everything is going to be okay I'm just stalwart about it. My pets help me learn new things. Sometimes I'm too busy or aloof to observe things around me. Then they'll do something and I'll realize what a beautiful way they dealt with the situation."

 Q & A

Do your pets have certain people they like or dislike? Occasionally, a man in uniform.

Do you dress up your pets? No

Do you consider your pets family members? Yes, I will always have at least two dogs. I can't imagine my life without pets.

Have your pets helped you make a new circle of friends? Yes, I've discovered other people with Jack Russell Terriers and Marilyn Sibley and her dogs. You get to know people better that have animals; they are a real ice breaker.

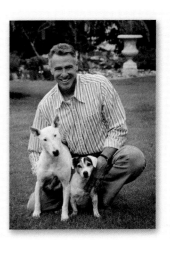

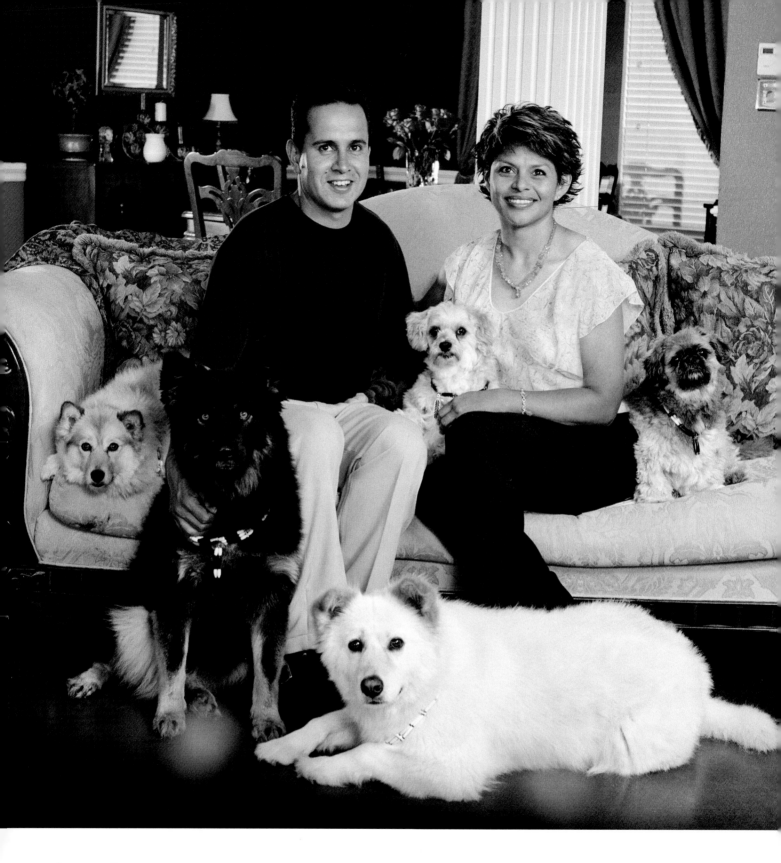

The Blanco family's story begins with Nellie Blanco's birthday several years ago. She and her husband, Robert, had wanted a dog for some time. Robert decided that they should do something nice for a dog that might otherwise not get adopted. The Blancos selected Bailey, a brown-and-black Lhasa Apso mix from the SPCA because he seemed unattractive to other people.

ROBERT & NELLIE BLANCO

Victoria, Boots, Kirby, Shelby & Bailey

While taking Bailey in for shots at the Hillside Veterinary Clinic in Dallas, the Blancos learned about Kirby, a whitish/brown-colored Poodle/Cocker Spaniel mix who had been struck by a car and was found with a crushed backside. Robert and Nellie assumed the veterinary bills for the poor pup and decided he should become part of their family.

Robert, in his line of work as a police officer, found Shelby, a cinnamon-colored Sheltie mix. She was tied loosely to a tree and was covered in fleas and ticks. Robert and Nellie treated Shelby and added her to the household.

Victoria, a white Chow Chow mix, was found at a construction site with her litter of six puppies. The Blanco's friend, Danielle, helped get the six puppies adopted, but the Blancos couldn't bear to see Victoria go.

Boots, a black Shepherd mix with four brown paws, found Robert while he was at work. Boots was terrified of the other officers but jumped right in his car when he beckoned her with some food. Boots now loves to play ball and lives to play catch. She is the most energetic dog of the five.

Nellie smiled and said, "It is so cute when Boots runs around all the time with her glow ball or tennis ball in her mouth; she is always ready to go outside and play!"

The dogs love to sleep and Kirby has his very own chair. The dogs are cuddlers and understand what "Let's go to bed" means. They all sleep in their dog beds or in bed with Robert and Nellie, whom they call Mommy and Daddy. Boots likes to sleep with her stuffed animals. One has to be right with her or she won't sleep. Her favorite stuffed toy is a big red stuffed Clifford dog. Victoria dutifully wakes up the family each morning with a huge bark.

In additional to having full run of the house (which the Blancos bought just for the dogs), when asked if her pets are spoiled, Nellie said, "The dogs get treats just about every time we go to the store or when it is one of their birthdays. They all get birthday cakes made especially for dogs. Their favorite treats come from Tails of the City and have icing on them. Birthday cakes come from Big Bark Bakery."

When asked the best part about having pets, Nellie said, "They have definitely all touched our inner souls in some way. They are very compassionate towards each other and that is very important for a family with five dogs. We are privileged to be their owners."

 Q &A

What are some cute things your pets do? Boots likes to sleep with her stuffed animals. One has to be right with her or she won't sleep. Her favorite toy is a big red stuffed Clifford dog. She also likes to run around all the time with her glow ball or tennis ball in her mouth and is always ready to go outside and play.

Would you call your pets compassionate? Yes, they are very compassionate towards each other and that is very important for a family with five dogs!

What touches your heart the most about your pet? They all get along so well with each other. Most of all, we know they love us and thank us for saving their lives, because they show us this by being such good dogs. They have definitely all touched our inner souls in some way. We are privileged to be their owners.

Do your pets have any heroic acts? I think all of our puppies are heroes, just for surviving out on the streets before we met! They had no food or shelter, and it's hot in Texas, with terrible summers and cold winters!

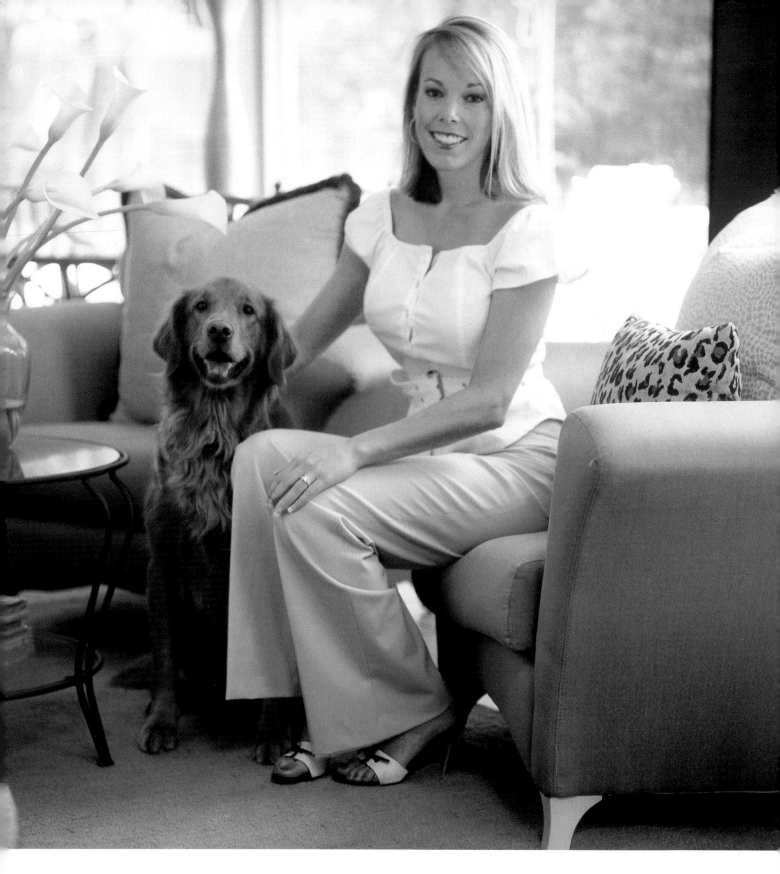

W hen it comes to great taste and perfect style, author and decorator Jolie Carpenter said the best way to liven up a room is to place pets in it.

JOLIE CARPENTER

& Max

Max, her seven-year-old Golden Retriever, adds warmth and comfort to her North Dallas home, where she enjoys relaxing by the pool or entertaining friends with publishing guru husband Brian Carabet. Jolie is a native Texan and takes a lot of pride in Texas. She says, "doing business in Texas has contributed to much of my success."

Jolie is the author of regional coffee-table books, including *Spectacular Homes, Dream Homes,* and most recently, *Spectacular Restaurants* for Signature Publishing Group headquartered in Dallas, Texas. Her books have been featured in countless magazines and television shows. Max's picture is published in all of them.

Jolie said, "Max is so graciously supportive; my life is so much richer with him in it! In my profession, I am in a lot of beautiful homes, which are more than just beautiful place to lives; they are all reflective of owners' and pets' personalities."

Jolie is also a licensed therapist and said that decorating should promote well being and that pets add dimension and calm to a home. She practices what she preaches in her own home by surrounding herself with soothing colors and textures reminiscent of the Caribbean resorts she and Brian enjoy visiting. Her home recently graced the cover of a Dallas magazine, which featured the "City Caribbean Style" she coined. And, yes, Max is also in a few of the homes interior photographs.

Max is definitely part of the family. Since he is an only child, he enjoys playing with Jolie's friends and other people's pets. Just like a child, Max is under her feet at all times. Jolie said that she enjoys taking care of him and keeps him on an organic diet.

Jolie said, "After a long day of production or out on a photo shoot, it is so wonderful to see Max's sweet face and that always makes me feel so good. Being at home with Max is relaxing to me and I hope I may share my story with others and encourage them to slow down and enjoy the simple things in life."

Q & A

Would you say your pet is spoiled? My friends say he's spoiled, but of course I don't think so ... what's wrong with getting him a Coach collar? Max also loves bones. Every time we go out to dinner we ask for a few bones to take home. It keeps him busy for at least an hour!

What are some cute things your pet does? Max dives off the diving board for tennis balls. He even goes to the bottom of the pool to get toys!

Do you consider your pet a family member? Yes. Max is featured in all our Christmas cards and I have his name on our answering machine. His picture has also been published in all my books.

Has your pet helped you make a new circle of friends? He always attracts people, especially when we are sitting on a patio in West Village. People will say, "He's so handsome.

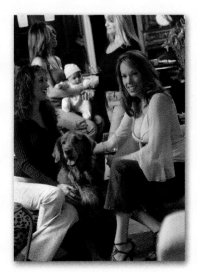

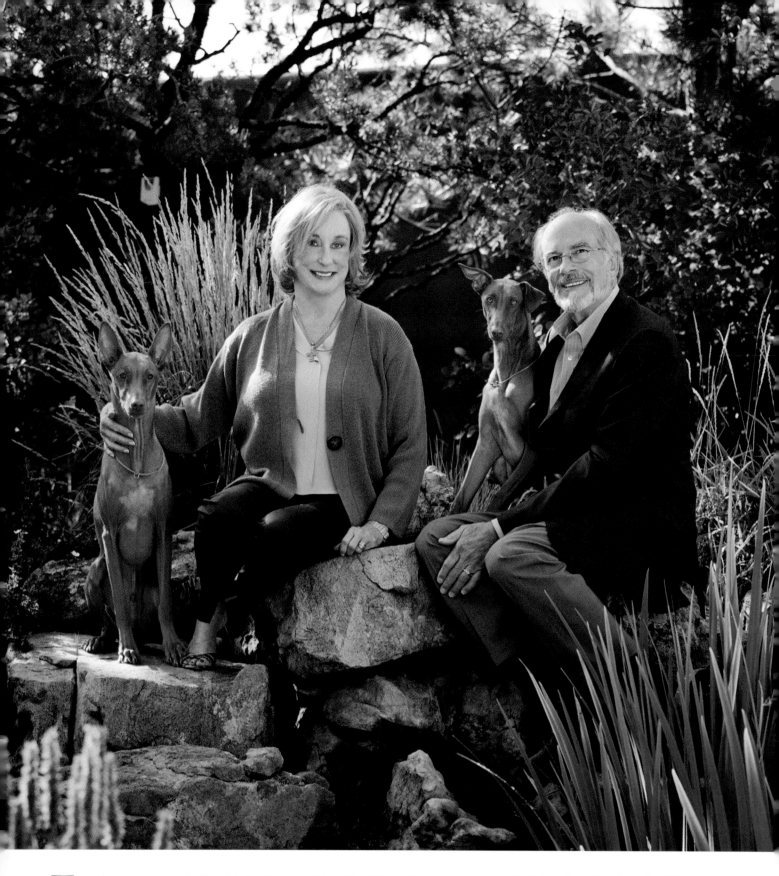

L ike many people, David Corley and his wife, Mary, first saw the breed of dog they liked at the Westminster

Show on television.

DAVID &
MARY CORLEY

Chili & Casi

They were smitten with the Egyptian Pharaoh Hounds and were attracted to the breed's statuesque, thin build. The dogs resemble Greyhounds. They are chestnut-colored with matching eyes. Pharaohs are sight and scent hounds and were originally owned and bred by Egyptian Pharaohs to hunt small game. For the past three thousand years they have been used on the island of Malta to hunt rabbits, hence they are fast runners and climbers with an overpowering urge to hunt.

The latest to the Corley family are Egyptian Pharaoh Hounds, Chili, age 3 and Casi, age 2.

Chili and Casi comfort the Corleys with their unique personalities and unrelenting loyalty.

David is a nationally renowned Interior Designer and Mary runs their antiques store in Santa Fe, New Mexico.

David and Mary love to talk with Chili and Casi. Chili has his own special language to communicate and Casi likes to sit there and listen, or perhaps she is just supervising.

The Corleys profess that their four-legged children are not spoiled, but the rest of the family would definitely disagree. Chili and Casi get something new every time the Corleys go grocery shopping for them.

Just like their parents, the pups know good design when they see it and enjoy snoozing in their own designer beds. They would never think of sleeping on the floor! David designed the dog beds to look like miniature sofas with matching covers and pillows. Of course, the dogs wouldn't have it any other way, since Dad is a top Interior Designer and he and Mom have an antiques store.

When the pups aren't busy getting some beauty rest, they anxiously wait for their parents and are sad when they see the Corleys preparing to take a trip.

Chili and Casi are happy to be involved in the *Texans and Their Pets* project because even though they may spend some time in Santa Fe, they really like Texas and want other dogs to know they can experience the good life any time. Just give their parents a call first.

 Q &A

Do you take your pets to work with you? We do not take the dogs to work, as they seem to think everyone would love to pet them and tell them how wonderful they are.

What are your pets' favorite toys or treats? They love squeaky toys which last about one or two days before they remove the squeaker. The treats they like best are freeze-dried liver or "Foie Gras" for pups.

Would you say your pets are spoiled? Not much, but our children would say definitely!

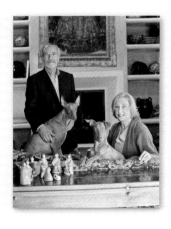

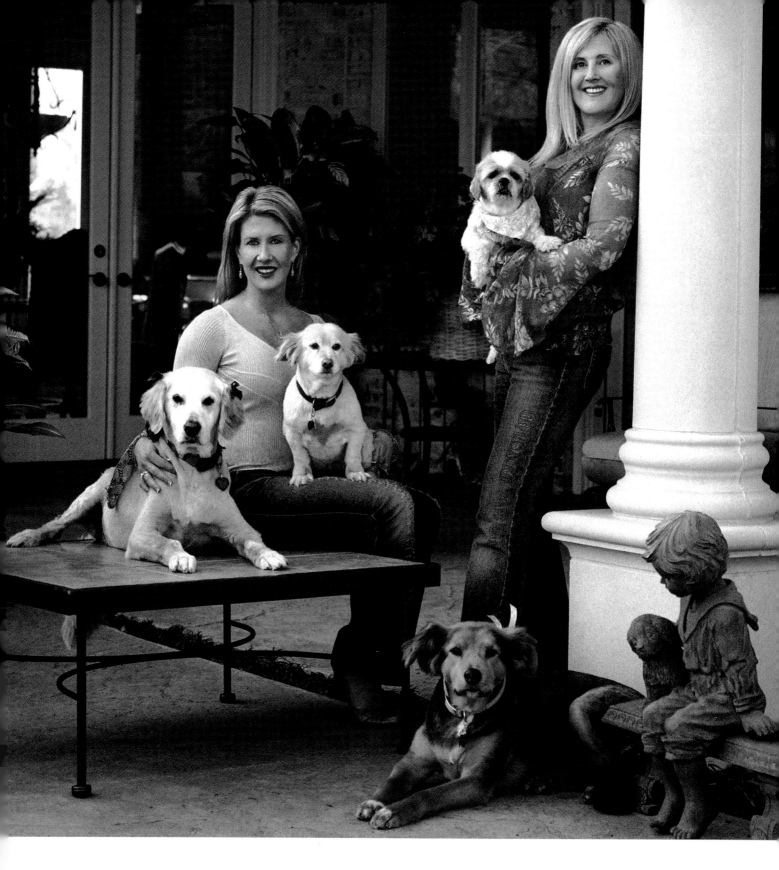

J uanita Couch and sister Tawana Jurek have helped rescue hundreds of homeless pets over the years; all the pets in their lives have been rescued from shelters or the streets.

JUANITA COUCH &
TAWANA JUREK

Shelby, Brittany, Callie & Pepper

Juanita has four dogs who dominate her home. Three of her four pets are pictured at left: nine-year-old Shelby, who goes to work with her, thirteen-year-old Brittany and three-year-old Callie. Tawana's life is filled with seven dogs and three feral cats. Pepper (pictured at left), her nine-year-old Shih Tzu rescue dog, had been intentionally set on fire and was diagnosed with a terminal disease. Today he is healthy and well and even has his own website and video at www.healthy healing.org.

Growing up in Dallas, Juanita and Tawana had dogs, but it wasn't until later that their love for animals became larger than life. Most of their children, as they call their pets, had previously been abused or seriously injured.

Juanita and Tawana recently formed a nonprofit organization, Society for Companion Animals, to help educate people about companion pets through film videos. They plan to take their videos worldwide and need volunteers and donations to help get this organization started (please call Tawana at 214-941-1014 for further information).

When asked if her pets are pampered, Juanita laughed, "Callie gets massages, Shelby goes to work with me at least three days a week, and Brittany and Callie watch Animal Planet all day long. When animals make noises on screen, Brittany will go lick the TV!"

The kids get chew bones and treats every day, and several times a week they get doggie ice cream. Shelby even has a life jacket for boating on weekends at their second home in Lake Granbury.

Tawana's crew gets walked two at a time. She said that what makes her feel good about her pets is that she took them from the worst conditions and gave them the "best of the best." "All of these dogs have been through such abuse, it is amazing they can learn to trust people again," remarked Tawana.

Describing a cute story, Tawana said, "Nellie is very organized and keeps her toys all in the backyard, but scatters them about daily. By late afternoon she picks up all the toys and returns them to her favorite corner of the yard." She continued, "My father came over one day and accidentally dropped his cell phone in the yard. We searched for it and finally looked in Nellie's toy corner, and minus a few chews, Dad's cell phone was still in working order!"

Discussing heroic acts, one weekend at the lake, Juanita's pup Shelby saw the neighbor's boat on fire and began barking. One of Tawana's dogs, Maggie, notified her by bad doggie behavior on her bed that a workman she had in the home was not a good person. Shortly thereafter, he was arrested and convicted of rape.

Juanita said, "My dogs are always happy, no matter what my mood is, and it's a comfortable feeling knowing they're always there for me." Tawana said that her crew has taught her to never give up. "They are my best friends," she sighed. Through tears, Juanita said, "Yes, they are my best friends, my comfort, and they make my life sweet."

 Q & A

Where do your pets sleep? Tawana's crew of seven all sleep in the bedroom, but only Pepper gets to sleep on her bed at her feet. Juanita has two doggie beds in her bedroom and Shelby has her own pillow and sleeps by her in the bed.

Have your pets ever comforted you? Tawana and Juanita both agree that their pets comfort them when they are sick or sad. Tawana said that Pepper will curl up on her stomach when he knows she doesn't feel good.

What touches your heart most about your pets? Juanita said, "I make them happy, spoiled and give them a great home." The sisters agree that their pets are sweet, always there for them and very loving.

Ginger, a six-pound, one-year-old, long-haired, golden Chihuahua, has brought great joy to Dr. Linda Crawford, an orthodontist located in the Park Cities. In a conversation with Linda, she'll most likely mention Ginger in the discussion. This precious pup entered Linda's life, by way of one of her patients, and now joins her at work attired in her own set of scrubs made by another of Linda's wonderful patients.

DR. LINDA CRAWFORD

& Ginger

Said Linda, "I start each day with prayer and thanksgiving for the gifts I have been given. Ginger starts each day by extending her little head out of the bedcovers and looking up at me with her big brown eyes. As soon as I pet her sweet little head, she rolls over and is ready for her morning 'tummy kisses'."

On the way to the office, Ginger puts on her "puppy face," complete with perked-up ears, glistening eyes and happy whimpers as she sits tall in her car seat. Each day, Ginger races from the car to the door of the office with the posture of a Greyhound ready to greet each staff person with snuggles and kisses. It is impossible to avoid smiling at her antics.

For Linda, Ginger has been a blessing which has changed her life and her practice. Her greatest impact is with Linda's patients. Said Linda, "The smiles on children's faces at the office are amazing! It seems to help them feel safe and secure in what could otherwise be known as the doctor's office."

When asked if her pet is spoiled, Linda replied coyly, "Yes, rotten! Every time I go to the store, she has to have something." Even Ginger's collar is truly one of a kind. Tying two of her loves in life together, Linda created a tiny collar of back-to-back crystal buckles taken from her retired ballroom dancing shoes that would make Elizabeth Taylor jealous.

Linda says that she feels unconditionally loved by Ginger and Linda's two sons. She said appreciatively, "Ginger reminds me to slow down, enjoy everyday life and relax. One day at the office, we were working late when Ginger came in with her favorite toy to remind me it was time to go home. So of course I stopped and we went home and played."

Ginger is also a loyal and compassionate friend. Linda said, "When I was healing from a recent surgery, Ginger was glued to my side. She is very compassionate when people are sick or crying." She continued, "Before Ginger came in to my life, I had terrible insomnia. Now, Ginger hears the quietest of sounds and alerts me if there is need for concern. This has helped me sleep feeling secure and peaceful. Ginger is a gift, a little angel, who is very adept at communicating her feelings of love, need to snuggle, or whatever else she desires."

Linda smiled, "My sons and my profession as an orthodontist have always brought me great joy. Ginger brought our family even closer and gave considerable peace and joy to a personal life that previously held its share of sadness. Now, I truly enjoy life every day."

Q & A

Is your pet spoiled? Yes, rotten! Even Ginger's collar is truly one of a kind with back-to-back crystal buckles taken from my retired ballroom dancing shoes that would make Elizabeth Taylor jealous.

Is your pet compassionate? Yes, she is a loyal and compassionate friend. When I was healing from a recent surgery, Ginger was glued to my side. She is very compassionate when people are sick or crying.

How has your pet changed your life? Ginger reminds me to slow down, enjoy everyday life and relax. One day at the office, we were working late when Ginger came in with her favorite toy to remind me it was time to go home. So of course I stopped and we went home and played.

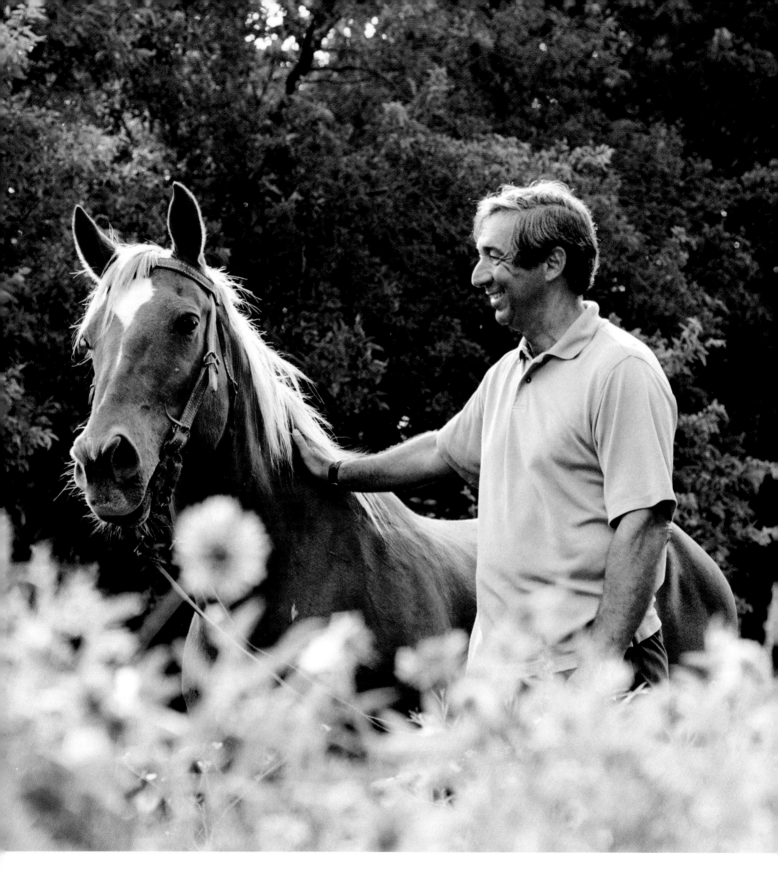

R ick Danna spends most of his time at the SPCA of Texas volunteering when he is not in court or working on real estate investments.

RICK DANNA

Sugar, Kitty, Boy, Suzy & Keeper

He also volunteers his time at Dallas Legal Aid, the White Rock Marathon, and is a regular blood donor at Carter BloodCare. Then, there is his incredible home on three acres that is any animal lover's dream. Outside, his registered Quarter Horse, Sugar, now in her early twenties, leisurely strolls across the pasture and will greet you at the gate. Rick grew up with a dog, but always wanted a horse as a boy. His dream came true when he got Sugar, a sweet pet that Rick rides now and then but has never raced.

Kitty is a former stray that sat on Rick's window sill outside his home office. Rick coaxed her for several years before he gained her trust. Now, at approximately ten years of age, she meanders into his office daily and joins him at his desk.

Thirteen-year-old Boy, a Labrador Retriever mix SPCA of Texas adoptee, enjoys running in the yard or relaxing in the house. He and Rick enjoyed the home alone until three years ago when Rick adopted Keeper, a beautiful Husky from Adopt A Husky Rescue. Rick soon became a SPCA volunteer and fostered dogs with minor illnesses. After fostering more than twenty special needs pets, he fell in love with three-year-old Suzy, a Manchester Terrier mix who maintains the status as lady of the house.

According to Rick, the cutest thing the threesome does is, "After a long run, I always fix pancakes, some for myself and some for the dogs. I cut their pancakes into pieces, sit on the couch, and Boy, Keeper and Suzy line up like two gentlemen and a lady. They each wait their turn for a bite without trying to steal each other's treat. It's amazing; they are just so polite."

When asked what touched his heart the most about his pets, Rick said, "Whenever I come home after a long day, which may be only six or seven hours that I'm away, they are so excited to see me. It's knowing they're always going to want to be with me; they will never try to avoid me. We communicate without words. They are so responsive."

"I probably have made more acquaintances because of Keeper always jogging with me. When we're together, other joggers stop us to talk, especially at the water fountains. We also get a lot of attention at the Jingle Bell Run each year," Rick said proudly.

Without hesitation, Rick introspectively said, "My animals are my family. When I'm on a trip, I always have a house sitter. I call home daily because I miss them so much. I just can't wait to get back home to see them. I hope they feel the same way." Undoubtedly, they do.

 Q & A

Are your pets spoiled? Yes! I've had to cut back on the Milkbone treats because Suzy and Boy have gained too much weight. Keeper stays lean and fit. They get rawhides and pig ears to chew on and sometimes Kongs filled with treats.

Do you feel that your pets can talk to you? We communicate without words. They are so responsive. When I transfer the phone at night to the bedroom, they immediately get in bed. All I have to do is clap twice and they know that means we're going outside.

Who do you run with? Keeper, but only in cooler weather, and on the days he isn't with me, I get stopped by the other runners who want to know where he is.

What kind of pet did you always want as a boy? A horse.

L ynn Townsend Dealey is a renowned animal lover (domestic or wild), philanthropist and professional

illustrator. She has provided drawings and paintings for the Dallas Zoo for more than twenty years.

LYNN TOWNSEND DEALEY

& Puss

Along with her commercial design work in newspapers, magazine and print media, Lynn's art has appeared at The Enchanted Galleries art gallery in Preston Center, and she paints commissioned portraits of pets and people with a whimsical style. Lynn said, "Making people smile is part of my artistic philosophy!"

Lynn loves all animals (except mosquitoes), but she has a soft spot in her heart for cats of all shapes and sizes, whether they meow in the kitchen or roar in the jungle.

Her female, blonde tabby cat, an angel named Puss, is in Kitty Heaven now, but she has forever left an indelible paw print on Lynn's heart. The charming personality and innate grace of this cat served as an inspiration for many of Lynn's pet illustrations over the years. Lynn laughed, "I always considered it the ultimate compliment that a mysterious, solitary creature like a cat would prefer the company of a lowly human."

Lynn found Puss as a tiny yellow-and-orange striped kitten in the parking lot of a Church's Fried Chicken, where the hungry animal was darting out from under parked cars, begging food from strangers. A smudge of axle grease stained the top of the kitten's head and took more than a year to disappear. Lynn rescued Puss with a kitty cage and a can of Pounce® cat treats as bait. Though Puss had clearly been abused in her young life, in time she trusted Lynn and they became fast friends for eighteen years.

Lynn said, "I believe animals are one of the last things on this earth that are unspoiled, beautiful without effort or ego, and have no agenda except what their survival dictates. Their efficient, graceful designs also inspire the artist to appreciate a Bigger Artist."

Lynn continued, "Many animal species also have the capability to love, in their own way, whether experts admit it or not. Watch your dog's face fall when you leave for work and light up when you return—that's emotional expression, however basic. Just because animals can't talk doesn't mean they don't feel."

Lynn said she loves the SPCA of Texas and other pet organizations because they do all they can to help the little ones. She is pleased to provide Puss's fuzzy little legacy for the Texans and Their Pets project.

Q & A

What made you laugh the most about your pet? Puss was a "prissy" walker; you could tell she was a girl kitty!

What touched your heart the most about your pet? As an artist, I loved to look at her. I never tired of studying her exquisite face and huge golden eyes (complete with perfect natural black eyeliner). Feline beauty is the ultimate beauty to me. I always wondered if Puss knew how gorgeous she was. Of course, her sweet nature was her biggest blessing to me.

What's the most important thing you learned from your pet? That God sends us who we need in our lives, with or without fur.

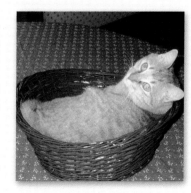

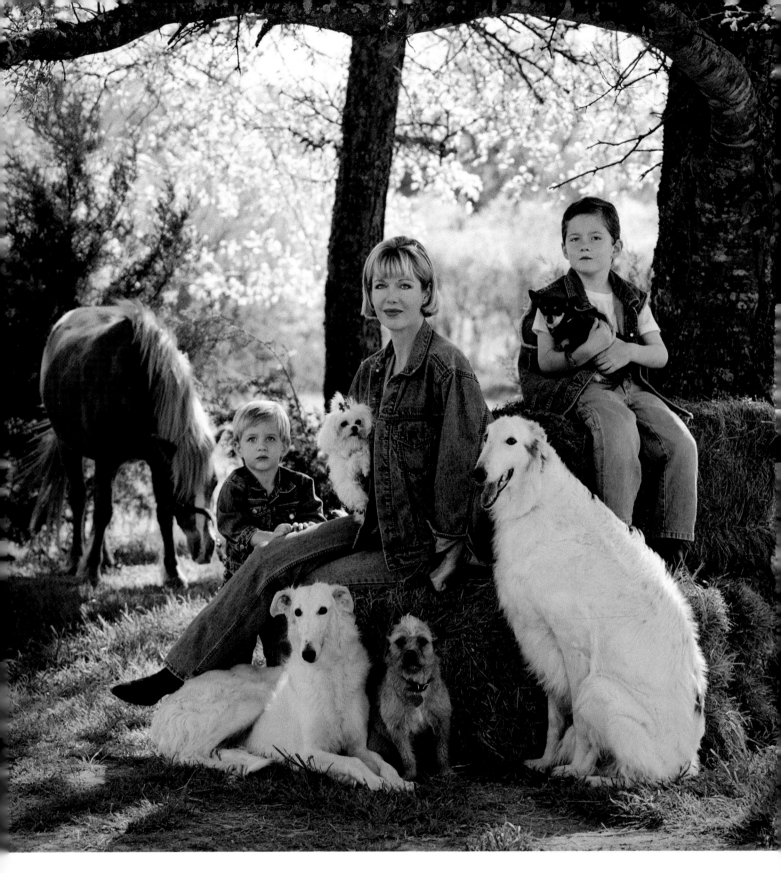

S uzen Dennis loves all animals. Just ask her extended family, Wolfhounds (Borzois), Lazar, named after a character from *Fiddler on the Roof*, Anastasia, Verushka and Delilah.

SUZEN DENNIS

Lazar, Anastasia, Verushka, Delilah
Carmen, Lola, Fred & Tinker

Carmen and Lola, Chihuahuas, Fred, a Terrier mix, and Tinker, a Maltese, are also members of the Dennis family.

Suzen's son, Julian, named the rest of the animals. He selected the names for their horses, Hercules, Spirit and Power Ranger. Additional pets to round out this spirited crew include Baby Jaguar, a kitten, Thumper (*Bambie*) and Freckles, their two bunnies. Ashton, Suzen's youngest son, would have helped name the pets, but he just enjoys being around them for now!

Said Dennis, "My pets are all very compassionate. They are members of our family. They have the ability to open their souls to you."

Just like most people, Suzen's pets eat natural, balanced meals and enjoy home-baked dog treats.

Suzen's pets have been a business inspiration to her over the years. Her passion for dogs led her to start Tailwaggers Country Inn, a luxurious pet retreat and styling salon, set on 27 acres of peaceful countryside.

According to Suzen, "I am always shopping and spoiling dogs. That's my job! Dogs are like little people with their own unique personalities." Continues Suzen, "I have never met a dog I disliked. I am truly blessed to know so many."

Suzen's pets love to make people laugh. One of her Chihuahuas has a tongue that is too big for her mouth. One of her Borzois (Russian Wolfhound) thinks she is a princess. Suzen's rescue dog, Fred, thinks he is one of the boys and enjoys swimming, running and chasing. He also loves to go on family camping trips.

Nighttime is special in Suzen's home. The pets rotate sleeping with everyone in the family and this is part of their "cuddle time."

Said Suzen, "I am so glad that pets are part of our family. They teach us unconditional love and help us learn and grow together. I am raising my two boys to respect all animals."

 Q & A

Do you dress up your pets? Absolutely! I spent several years as a fashion model, so you can only imagine!! My dogs have been in print ads, and on the fashion runways ... mostly as accessories themselves!

Any heroic acts? My four Borzois (Russian Wolfhounds) are a great source of protection and security for myself and my family.

What is one of your cutest pet stories? I was helping with pet adoptions in Dallas one year, and the boys came to see what pets were available. For four weeks in a row, Fred (a Terrier mix who is so ugly he is cute) sat in his cage trying to look handsome! Julian, then age four, asked, "Mommy, why can't we give Fred a home?" Within thirty minutes we drove off with my two little boys, and in between them, a little Fred smiling ear to ear.

U pon first glance, one might think Diane and Rory Divin's Salukis are a cross between a cheetah and a gazelle.

DIANE & RORY DIVIN

Sala, Moosie & Isadora

Beautiful, tall and delicate, mostly muscle and bone, these dogs date back to 5000 B.C. and are known as the Royal Dog of Egypt. Diane adopted her first Saluki, Suzi, in 1982 from the SPCA of Texas in Dallas. She became so enamored of the breed that she studied and researched the Saluki as well as traveled to meet breeders and see shows in countries around the world.

Since then, the Divins have had many Salukis. Diane raises, shows, and enters her pets in lure and open field courses around the country. A member of multiple Saluki organizations, she was one of the founders in 1986 of the National Saluki Rescue Network.

Today, the Divin home is filled with the royalty of thirteen-year-old Sala, six-year-old Moosie, and one-year-old Isadora.

When asked if her pets are spoiled, Diane said, "I wouldn't say so, but everybody else does, including my husband." Rory quietly added, "Well, she cooks a special diet for them, and they have their own air conditioned and heated, faux-finished dog palace with stereo when we are not at home."

The Saluki is known for being rather aloof, but Diane said the dogs are very in tune with their family and dear friends. She paused, and then with tears said, "Moosie is one of my best friends. He and I have done so many shows and courses together, there is such a thrill in winning, and watching him in action when he hunts." In fact, Moosie has one of the most difficult titles to obtain, Coursing Champion, and he placed second in the 2003 National Open Field Coursing Association's Grand Course Breed Hunt.

Diane said she breeds for the Saluki's original function as a hunter with good temperament and good companionship. These dogs can run 35 or more miles an hour for up to five miles. To watch them stalk each other, play and race across the Divin's two-acre yard is a thrill for anyone to see.

Rory's favorite time of the day is coming in, changing to his casual clothes, and getting in "a pile on" in the middle of the floor. He said they hang out together at night on the couch and get cozy and just relax. Diane appreciates their stature and demeanor saying, "They are sensitive, gentle creatures, deer-like and very polite."

Rory said, "It's how loving and responsive they are; how much they really care about you and the devotion that they show. They help you learn about love." Diane said she has always felt a spiritual connection to animals and nature, especially dogs in general. She said gently, "Salukis fit my soul and who I am; they fit me and my lifestyle. They are beautiful on the inside and a work of art on the outside."

Q & A

What is the most important thing you have learned from your pets? Patience! How to relax and go with the flow; they're very good at that. It is that unconditional love; there is nothing like it.

How often do you buy your pets something? Just about weekly, the dogs have their own toy boxes.

Do you consider your pets family members? Yes, they are our children, the only ones we have.

Have your pets helped you make a new circle of friends? Absolutely, because we show, do coursing, breeding and rescue work. We have friends all over the world and have email conversations internationally.

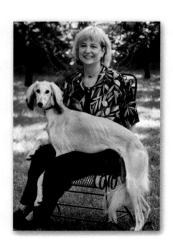

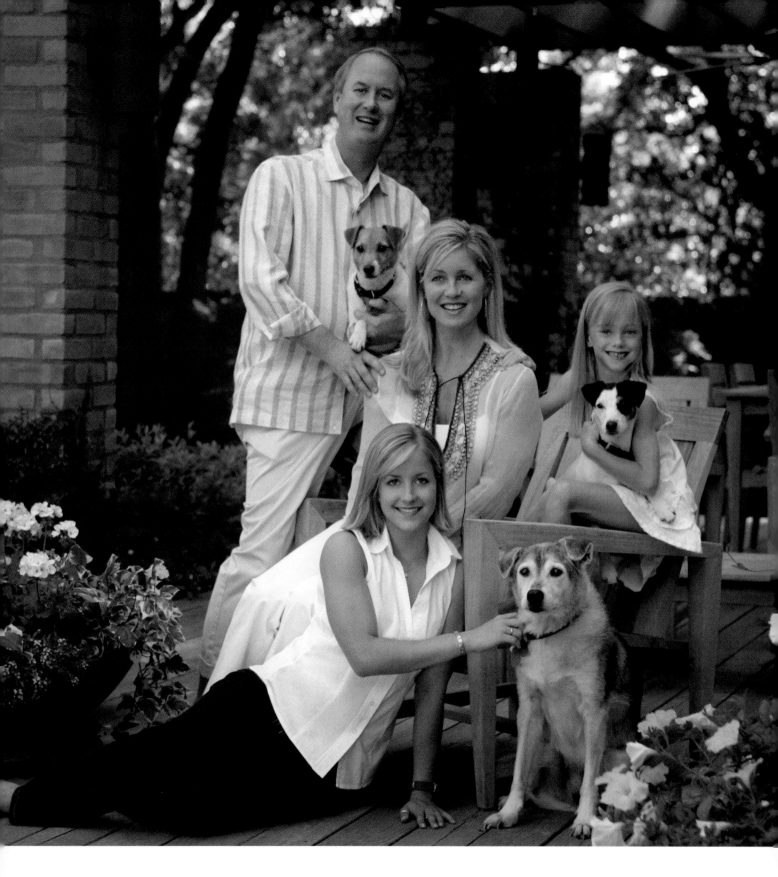

J ennifer and John Eagle are the proud parents of four girls. Amanda spends her days attending college in Florida, Alexandra is in the second grade and the two youngest, Isabella and Lulu, are Jack Russell Terriers who spend their days chasing squirrels.

JENNIFER & JOHN EAGLE

Isabella, Lulu, Roxanne & Bud

Isabella and Lulu are rather recent additions to the Eagle household.

Lulu, age four, was a special gift from a grandmother, now deceased, who wanted the children to have something to remember her by. Lulu has a brown-and-white broken coat.

Isabella, nicknamed "Isabella Donatella," is still a puppy and will soon celebrate her first birthday. She has a mostly white smooth coat and a distinctive black eye, like the RCA dog. The Eagles added Isabella after the recent deaths of their beloved Great Dane, Roxanne, and Husky/Shepherd Mix, Bud. They wanted Lulu to have a playmate.

The dogs are mostly known for their gregarious, spontaneous, playful, loving personalities. They are always happy and love to meet new people. Said Jennifer, "They are just so sweet and fun, after a hard day's work of play, they are ready to get cozy."

The dogs have a sensitive, sweet side, and are always ready to give lots of kisses. The dogs also love to snuggle and sleep at the foot of the Eagle's bed.

When not busy playing, the dogs are hunters and protectors. They love to chase squirrels in the yard, which often pelt them with acorns and taunt them at the window while inside. The dogs have lots of personality and are full of spunk.

Lulu and Isabella will often climb to the back of a chair or sofa and will try to wrap themselves around guests necks. "They are like little goats," said Jennifer. "They like to be up high so they can see everything going on around them."

Lulu and Isabella are definitely a big part of the Eagle family. The Eagle's youngest daughter refers to the dogs as her "little sisters." They get lots of treats and love anything chewable. Isabella loves to sneak into Alexandra's room and chew on the stuffed animals.

According to Jennifer, she couldn't imagine life without dogs in the house. "They are a big part of our lives," she said. "We've always had big dogs, Great Danes, Husky Mixes, Black Labradors, but wanted small dogs we could travel with. Jack Russell's think they are Great Danes."

Q & A

Where do your pets sleep? At the foot of the bed. Lulu snores!

Do you consider your pets family members? Absolutely! They are part of our family.

What's the most important thing you've learned from your pet? They ask for little and give a lot.

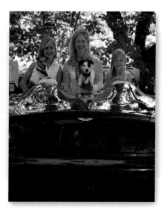

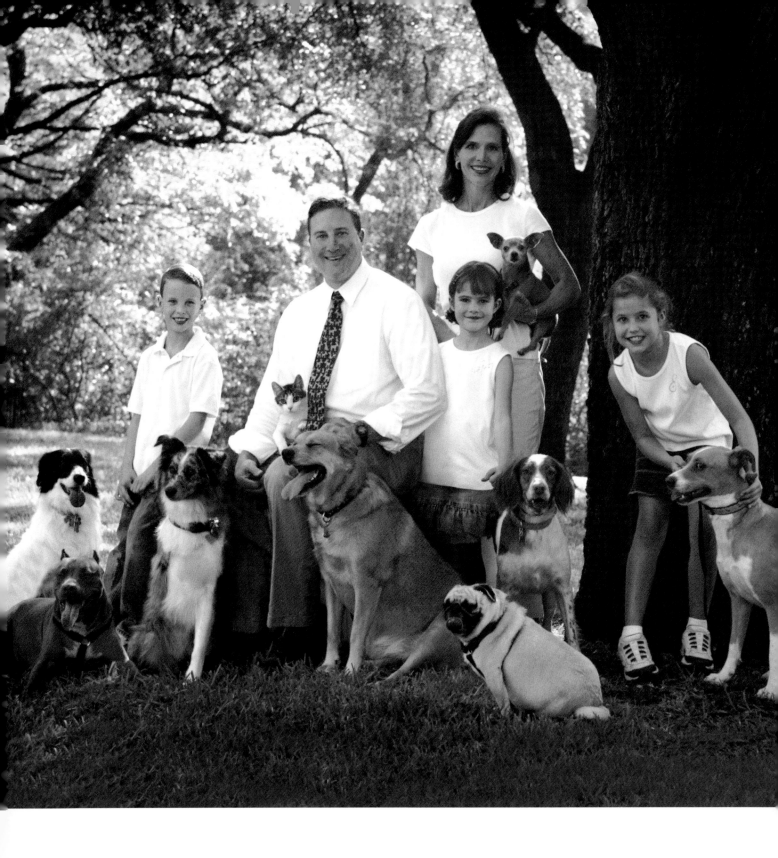

D
r. John Vandermeer and the staff of Highland Park Animal Clinic are long-time supporters of the
SPCA of Texas and animal welfare in general.

HIGHLAND PARK ANIMAL CLINIC

George, Pedro, Ed & Harley

Dr. Vandermeer and his team make it their business to bring health and happiness to hundreds of pets each year. Clients and pets are usually greeted on a first-name basis at the clinic, and a spirit of friendliness and cheer welcomes folks who may not be there at the happiest of times.

Dr. Vandermeer realizes that there are, unfortunately, ill, injured and abandoned pets that face an uncertain future. The SPCA of Texas does its best to aid all animals, but there are some creatures that would not make it, save for the grace of the benefactors of Highland Park Animal Clinic. Many animals rescued by the SPCA are in need of costly or complicated surgical procedures for which there are no means of payment and/or no one to foster them during their recovery.

Recognizing a need, Dr. Vandermeer and the Highland Park Animal Clinic (HPAC) courageously began a benefit partnership with the SPCA of Texas entitled the "Hard Luck Hound and Kitty Society" in 2002. The program allows HPAC to treat one injured or disadvantaged SPCA animal each month at no cost, with the hope to increase the number served over time. More than sixty-five pets have been treated to date.

According to Dr. Vandermeer, "Our staff wanted to recognize the years of love and devotion our pets and our clients' pets have provided and this is our way of giving back to the community."

The SPCA pets chosen for the no-cost rehabilitation are given names corresponding to the letters of the alphabet. As each pet is treated, Dr. Vandermeer and his staff select a name that corresponds with the next letter in the alphabet. A wall of fame adorns the walls of the clinic to commemorate each pet.

HPAC veterinarians will perform life-saving surgeries for the dogs and cats that have suffered various traumas such as bite wounds, burns, falls, abuse, congenital deformities or injuries.

Further, HPAC staff will give medications, change bandages and provide much needed tender loving care for patients in the post-operative period. Finally, when the animals have regained their strength, the HPAC Day Spa will help further restore a pet's spirit and beauty so that it will be ready for the best adoptive, permanent family possible.

The SPCA of Texas is grateful to veterinary clinics and angels such as Highland Park Animal Clinic.

Personally, Dr. Vandermeer is on the Board of Directors for the Dallas County Veterinary Medical Association and has held several volunteer/consulting positions. His wife, Wendy, is also a veterinarian who joins him at the practice several days each week. The Vandermeer's family would not be complete without pets George, a Labrador, Pedro, an English Cocker Spaniel, and tabby cats, Ed and Harley. Multiple frogs and fish complete the Vandermeer crew.

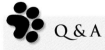 Q & A

What year was HPAC founded? We were founded in 1964.

What are the names of your staff? We have a terrific team with Sue Brown, Bobbie Reilly, Sheri Guthrie, Karen Bellamy, Arturo Gonzales, Maria Rosales, Stephen Barry, Shanda Mize, Robert Watson, Katy White, Paige Redding, Kerry Kores, Dorothy Stephens, Jill Harrington, John Vandermeer, DVM, Wendy Dearixon, DVM, Ben Morse, DVM, Gary Harrell, DVM and Polly Dixon, DVM.

How many pets a year do you treat? We treat numerous animals each year and they are all special and important to us.

Where are you located? We are located at 5323 N. Central Expressway, Dallas, TX 75205. Our phone number is 214-528-3360.

D r. Brad Hines is a veterinary medicine specialist and consultant who has helped numerous pets across the country. He enjoys helping pets that are supposedly beyond help.

DR. BRAD HINES

& Big Nate

Dr. Hines' pet family currently consists of Nate, a nine-year-old white-and-gray Shih Tzu who goes to work with him almost every day. Lamb Chop, Dr. Hines' personal pet, sadly passed away in 2003.

"Big Nate," or "Buddy," as he is often called, actually belongs to Dr. Hines' grandmother, Margaret Estep, but they try to visit her often. Big Nate lived with several different relatives before joining Dr. Hines. He said, "Big Nate had been through five families before we wound up together and yet he remains such a happy little dog."

Big Nate is very friendly and sensitive. He loves to give kisses to everyone and seems attuned to people's moods. When asked if his pet has ever comforted him, Dr. Hines said, "Absolutely, on a daily basis! Big Nate is adorably cute and makes me smile, especially if I've had a tough day. His tongue also sticks out a little."

According to Dr. Hines, Big Nate is more spoiled than any other pet he's ever had. He has a food bowl with his name on it, toys, a jean jacket and bomber jacket. He gets a new squeaky toy at least once a month. His favorite treats are bacon (the real thing!) and grilled chicken. Big Nate also has his own bed but often sleeps at the foot of Dr. Hines' recliner or even in bed with him.

Dr. Hines continued, "One of the cutest things Big Nate does is when he gets excited he quivers all over. He makes me laugh the most when he plays with his toys. The most important thing I have learned from him is that there is always time to play."

When asked if his pet has touched his inner soul or inner being, Dr. Hines was quick to respond that he is "Dad" to Big Nate and they have a common bond that allows them to understand each other.

He said, "We are attached. I truly love him. I love all animals. My choices for a degree were veterinarian, pediatrician or an anesthesiologist. As a veterinarian, I have the best of all worlds! I work with creatures I love and deal with people who love them."

Dr. Hines said the best part about his job is sending a patient home who was sick when he arrived and was supposedly beyond help. Dr. Hines also enjoys meeting pets' parents and seeing their joy and relief if and when their pets can go home.

Q & A

Is your pet spoiled? Yes, he has a food bowl with his name on it, his own bed, toys and a jean jacket and bomber jacket.

What are your pet's favorite treats? Bacon (the real thing!) and chicken. He likes to eat what I eat.

Can your pet talk? Big Nate howls when I instigate the howling. He understands a lot of words too.

What is something cute that your pet does? His tongue sticks out a little. He gets so excited when playing with a toy that he begins to quiver all over.

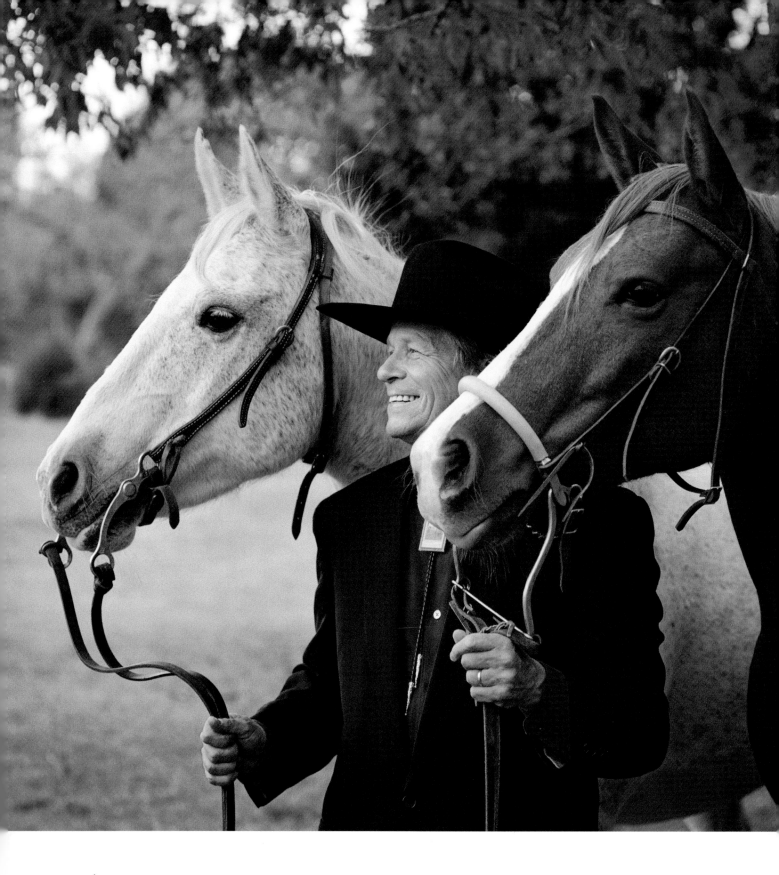

Ali Baba, Sherrye Rochester, Mary Ellen and Classic Sierra are special friends (pets) that have changed Bob Hopkins' life.

BOB HOPKINS

Ali Baba, Sherrye Rochester Mary Ellen & Classic Sierra

According to Bob, "As a child, I always wanted a horse, what child doesn't? Like most children, I never got one, but instead went to summer camp for several years at Skyland Camp in Gunnison, Colorado, where I always took the blue ribbon for Horsemanship. Continued Bob, "This meant at age eleven, I could sit up straight in the saddle and make the horse do what I wanted it to do with some sense of control." Bob's camp horse was named Carmen and was a granddaughter of Kentucky Derby winner, Man of War.

It wasn't until Bob was forty years old that he finally got to satisfy the childhood dream of owning a horse.

Said Bob, "I visited my relatives at their farm in Kansas, and found Ali Baba abandoned by my cousins who were in high school. They were more interested in sports and the opposite sex and left Ali Baba all alone."

Ali Baba would look over the fence all day, waiting for someone with whom to play. Bob's cousin, Kathy, the mother of the teens, felt sorry for Ali Baba and saw the "I want a horse" twinkle in Bob's eye. She said, "Bobby, you and Ali Baba belong together! You take him back to Dallas and ride him and love him every day!" And Bob did. Ali Baba has changed Bob's life. He soon learned the proper care for a horse and adopted several more.

Sherrye Rochester, Bob's third horse, is a registered Polish Arabian. She is the daughter of Cricket Heather who died of West Nile Virus and was named after Sherrye Banks, Bob's good friend, educator, philanthropist and championship horsewoman. Sherrye died of cancer three days after Sherrye Rochester was born. In appreciation for Sherrye Banks and her love of life, Bob named Sherrye after Sherrye. On Sherrye the horse's first birthday, Bob and his friends had a special shower for her. Horses from yon and far paraded across the pasture to the tune of Sherrye, Sherrye Baby, Sherrye, Sherrye Baby.

Bob is hopeful that Sherrye Rochester will provide a filly in 2007, so the legacy will continue. In addition to Sherrye and Ali Baba are Mary Ellen and Classic Sierra. Mary Ellen was purchased along with two other fillies one snowy night in Dallas. Mary Ellen was named in honor of Bob's cousin, Mary Ellen Martz.

Classic Sierra was in the show ring as a Championship Quarter Horse. He is coal black in color and has a white star on his forehead. Class, as Bob calls him, is seventeen hands and a big champion. Class fell off a loading truck one afternoon and broke his hip. After six months of traction, Class could never enter the show ring again, but instead still thinks he's in the ring at Bob's thirty-three acre ranch, which is leased from Ma and Pa Kettle Pemberton on Pemberton Hill Road.

 Q & A

What are some special aspects about your horses? The four horses Bob presently owns are a labor of love. The two featured in the photo have special meaning because of the way in which they entered Bob's life and satisfied Bob's ultimate childhood dream.

Where do your horses live? All four horses are living in splendor in the grass (clover) with a fresh water pond near the Trinity River in Dallas. Bob gives a birthday party for ten children as a silent and live auction item to benefit charitable causes. Bob's next horse will be named *Phillyanthropy.*

What is another unique horse story? Mary Ellen was named in honor of Bob's cousin, Mary Ellen Martz, who gave Bob money for a birthday present, which he in turn used to buy his beautiful half breeds, Quarter horse and Thoroughbred. Mary Ellen the horse acts a lot like the real Mary Ellen who never likes getting caught. She dances around and around with her neck arched and has high 'steppin legs. She is a beautiful sorrel with a white blaze.

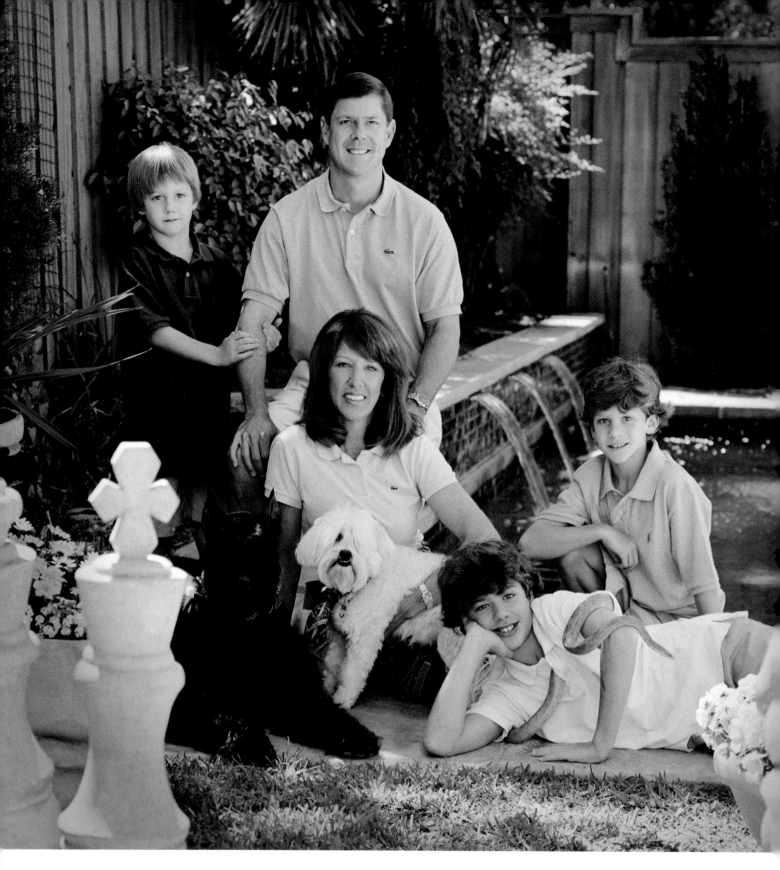

At Danielle and Jeff Howard's home, guests may expect to be welcomed and "checked out" by two very important family members. Lillie, a four-year-old Giant Schnauzer and Cookie, a one-year-old Havana/Bichon mix may bark, but guests will soon be greeted with kisses and two new best friends, unless it's the mailman or someone wearing a baseball cap.

DANIELLE, JEFF, WHIT, HANK & GUS HOWARD

Lillie, Cookie & Corny

At Danielle and Jeff Howard's home, guests may expect to be welcomed and "checked out" by two very important family members. Lillie, a four-year-old Giant Schnauzer and Cookie, a one-year-old Havana/Bichon mix may bark, but guests will soon be greeted with kisses and two new best friends, unless it's the mailman or someone wearing a baseball cap.

Danielle was not raised with animals because her military family moved often. Jeff had allergies growing up and even today any animal family members must be non-shedding. All three boys, Whit, Hank, and Gus have been raised with a menagerie of animals. Saving squirrels, stray dogs, lizards and snakes, the Howard family can truly be deemed animal-friendly.

Jeff and Danielle's first pet was a Giant Schnauzer, an SPCA of Texas adoptee named Gertrude. She lived until she was fourteen, and recently passed away. Lillie came from Arlington and Cookie joined the family during Thanksgiving of 2004 when Danielle and the boys rescued her from Dallas Animal Control. Other pets to round out the Howard family include Goober and Peanut, Hank and Gus's guinea pigs; and Whit is quite the herpetologist with pets. Corny, an orange corn snake who is now close to five-feet long, and Harry, a rather hairy tarantula.

"Our pets are definitely spoiled; nothing is off limits," says Danielle. "The dogs ride in the school carpool once a week and they sleep with the boys, though many times they do end up in our bed, much to Jeff's chagrin."

Whit's seventh grade carpool of boys love Lillie's antics. She is known to casually take tennis balls from Danielle's bag and drop them out the window, only to grab another, drop it, and repeat the process.

Cookie, probably mistreated by her first owners, has come a long way from staying under the bed or couch and hiding her food, to now greeting strangers, playing and cuddling in Danielle's lap. Her change in behavior touches Danielle's heart, as Cookie becomes more trusting and her personality blossoms.

When asked what the family has learned from their pets, Danielle answered, "Compassion and selfless love. That's important to see, especially when so much emphasis is put on 'me, myself and I' these days. Also, we have never allowed our guys to mistreat any of God's creatures and I know that carries over to how they treat friends, family and acquaintances. Each one of our pets has touched our souls in different ways. "

Q & A

Do you feel that your pets can talk to you? Whit is Lillie's voice. He has his own dialogue for Lillie's many expressions, which brings an enormous amount of comedy to family and friends.

Do your pets have certain people they like and dislike? They do not like the mailman. Lillie doesn't like ball caps on men.

Have your pets performed any heroic acts? Whit says that Corny sometimes scares away unwanted guests and people that overstay their welcome.

Do you dress up your pets? The boys dress Lillie up as a football player or other sports player, depending on the season.

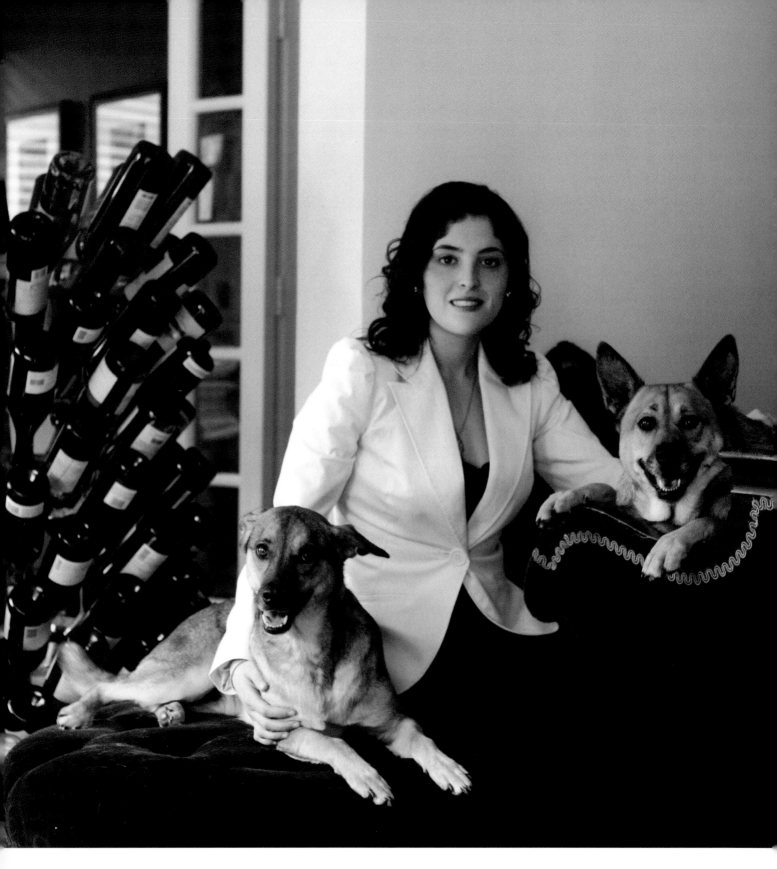

Stephanie LaBarba is the proud mother of two rescue pups, Charlie and Francie. Charlie is a sweetheart dog that found Stephanie and her mom, Leslie, in front of a restaurant in the parking lot of the Casa Linda shopping center in East Dallas.

STEPHANIE LABARBA

Charlie & Francie

This Australian/Shepherd mix was about to be dumped by a family and was dirty and had a tick. Charlie showed evidence of having been abused early, but due to Stephanie's love and care, she has made a full recovery. Charlie got her name because even though she is a girl, she is a bit of a tomboy and loves to roll around in the dirt.

Stephanie's other daughter, Francie, also a Shepherd mix, is an SPCA adoptee who was happy from the minute they got in the car to make the trek home from the shelter. She has an incredible spirit and the exact opposite personality from Charlie, but the dogs get along great and love to play all the time.

Francie is also a girlie girl, and loves to prance in front of the mirror and model doggie couture such as winter coats and collars with hand-applied rhinestones. She watches her slim figure by adhering to a diet of granola and carrots. The dogs both enjoy cherry and apple-flavored popcorn from time to time too. Francie's exercise regimen includes chasing squirrels with Charlie, swimming in the kiddy pool and striking poses. She loves doggie perfume and has a beautiful smile.

Charlie's favorite form of exercise is called the "waggle dance," or what the LaBarbas call the "Cha Cha." Her whole body seems to move when she gets excited. Charlie can also sit on one hip when she is trying to be cute.

"Charlie is really a free spirit," said Stephanie. "Both of my dogs are so expressive and playful. They are like little children to me and help make our house a home."

Stephanie is glad the right pets found her family and the LaBarbas are proud to be part of the *Texans and Their Pets* project. The story of Charlie and Francie is a perfect example of rescue pets finding the perfect connections with their owners.

Said Stephanie, "I am so grateful for the SPCA and all the work they do from investigations to helping with fleas and basic animal care. Animals can't speak and ask for help but somehow the SPCA finds them and speaks on their behalf. Thank you so much."

 Q & A

What is the cutest thing your pets do? Charlie has a "waggle dance" that the LaBarbas call the "Cha Cha" and Francie loves to strike poses in front of the mirror. Francie also has a beautiful smile.

Are your pets spoiled? They are very spoiled. Francie especially wants everything to be about her. She loves to get new collars and loves to look in mirrors. Both dogs love to wag their tails when they go for walks.

What do your pets call you? Stephanie is "Mom" to the pups and Stephanie's parents, Lucian and Leslie, are "Grammy and Grandpa."

Have your pets ever comforted you? "Yes," said Stephanie, "Their just being around makes every day entertaining."

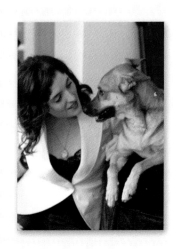

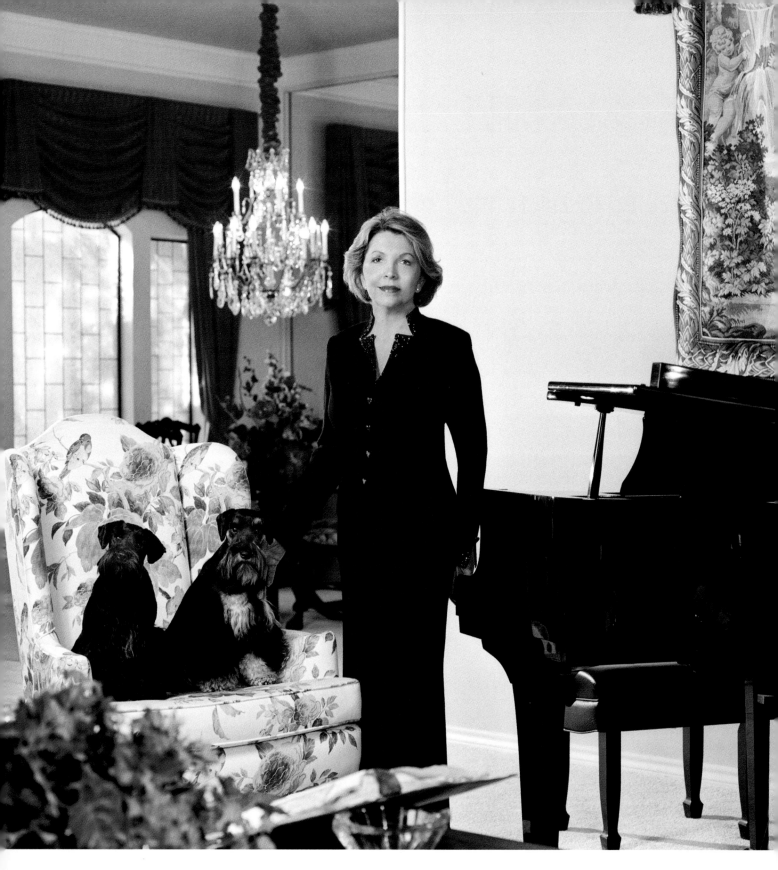

L oretta Littlejohn, a North Dallas real estate broker with Keller Williams Realty and true animal lover, is sometimes a Guinea Fowl rescuer in her spare time. The breed, which resembles giant turkeys, is originally from Africa. Perhaps the Texas summers remind the birds of their native continent!

LORETTA LITTLEJOHN

Luke & Lacey

Birds seem to know how to find Littlejohn; she once rescued a little red hen from certain death on Preston Road. Littlejohn was dashing to a listing presentation and saw the little chicken darting between cars in a parking lot. She called the SPCA and the bird was relocated to a home in the country.

Loretta has fed and nurtured two particular Guinea Fowl, FSBO and RELO, for more than seven years. If Loretta ever sells her home, the Guinea Fowl will come with the sale. Besides the pair's antics and sounds, she enjoys seeing a bit of nature in the big city.

The guineas hatch up to nineteen babies (keets) in the spring and again in the summer, which they promptly lead down to shrubbery at Loretta's house. Neighborhood cats and dogs would surely eat the keets if it weren't for Littlejohn's rescue efforts. She catches them all and releases them on a friend's farm.

This critter-loving agent goes the extra mile with her clients' pets too, and has been known to feed Nurse sharks, flop-eared rabbits, box turtles, a pot bellied pig named Ribs, and other creatures while clients were on vacation. Said Littlejohn, "One of my favorites is a tiny chocolate poodle named Starbuck who wraps her paws around your neck and gives you a big hug."

Littlejohn's home is also the palace of one-year old siblings, Luke and Lacey, two beautiful Miniature Schnauzers. Littlejohn originally had Miniature Schnauzers, Max and Liza, for many years, but upon their promotion to doggie heaven, she waited a little more than a year before she adopted Luke and Lacey at eight weeks of age.

Of all God's creatures Loretta has helped over the years, Luke and Lacey get the most attention. Said Littlejohn, "They are great morale boosters since they provide unconditional love and are sensitive to my emotions.

When she's not busy tending to animals or addenda, Littlejohn said pets have helped her make a new circle of friends and clients. "I deal with pets every day in the real estate business. I have found that you can learn a great deal about people by observing how they treat their pets and animals in general. People who are kind to their pets usually make wonderful buyers and sellers. Many times we correspond long after a home is purchased or sold. We keep up with each other and our pets."

"I am so blessed to have an opportunity to help make a difference in lives of both people and God's creatures".

Q & A

What is the strangest animal you have ever taken care of? I fed Nurse sharks for a client who was on vacation.

How often do you buy your pets something? Almost every week at one of the pet stores.

Do you cook for your pets? I buy pet food from the health food stores.

What makes you laugh about your pets? Their expressions when you talk to them and the way they love to play in the sprinklers.

Phil and Deirdre Marr are the proud parents of Pumpkin, a Standard Dachshund/Corgi mix, Cappy, a Cardigan Welsh Corgi, and Hogan, a Doberman.

PHIL & DEIRDRE MARR

Pumpkin, Cappy, Hogan, Bobby Jones, Traveller & Danny Boy

They also have horses, Bobby Jones, who is a Double registered Tennessee Walking Horse and Spotted Saddle Horse they purchased in Arkansas, Traveller, a Tennessee Walking Horse from Wills Point, Texas and Danny Boy, a Thoroughbred gelding from Pennsylvania. The Marr abode is also home to multiple fish tanks.

Pumpkin is a bona fide SPCA of Texas pup who is more than eleven years old. Deirdre was a volunteer at the time and fell in love with Pumpkin and adopted her. Cappy came from a breeder in Virginia. Hogan came from a local rescue group. His former owners had given him up because they moved into an apartment and the wife became pregnant.

The Marrs co-own Park Cities Obedience School and Dog Day Care, so love and discipline are very important in their household.

According to Dierdre, "I spoil the animals more then Phil does. If I had my way the dogs would be allowed on the furniture with us. But they're not so spoiled such that they get away with bad behavior. The dogs are very obedient and polite. They are the star guests at our annual Christmas party. We put food out all over the house and the dogs never go near it. They meet and greet but don't jump on people or get in their faces."

Continued Dierdre,"The horses are as spoiled as horses can be too! We give them TONS of treats (we buy apples and carrots in bulk at Sam's Club) and also give them alfalfa cubes and special crunchy horse treats."

The pets are part of the Marr family and are considered their "fur kids." According to Deirdre, "Hogan smiles when Phil comes home, and literally has this huge grin on his face with his teeth showing and the corners of his mouth wrinkled back, while he's smiling and dancing around Phil in a circle. The dogs love to run and play with each other just like children."

According to Phil, the best part of having pets is, "Knowing that we take the best possible care of them. Plus they're always glad to see us even if we've only been gone for ten minutes!"

Dierdre agreed and added, "I feel that my animals have made me a better person, more compassionate and more balanced. I feel 'whole' with them and I can't imagine living without dogs and horses in my life."

 Q & A

Do you feel as if your pet can talk to you? Absolutely! Cappy uses different barks to tell us things and Pumpkin uses body language, expressions, etc. to communicate. Even the horses have ways of talking with us.

Would you call your pets compassionate? Yes, I think they are very compassionate. When one of us doesn't feel well, the dogs stay closer to us and are very quiet in the house (not asking for as much attention), yet they will just lay right with us and keep us company.

What do you call yourself to your pets, i.e. Mom/Dad, etc.? We call ourselves the parents and my Mother is the "Grandma." The dogs know what it means when we ask them if they want to go see Grandma, they get really excited.

Do you dress up your pets? Absolutely! The dogs wear Halloween Costumes and Santa hats at Christmas. We even have Santa hats for the horses! They attach to their halter or bridle, you can even ride with them on.

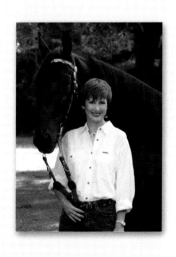

Joni McCoy grew up as a cat person, but her future husband, Mike, was a dog person and was highly allergic to cats. When Mike proposed marriage, Joni was ecstatic, but she knew she had to figure out what to do about her kitties. Luckily for them both, her parents lovingly accepted her two purr partners into their home in Arlington.

JONI, MATTHEW & MADISON McCOY

& Katie

Because Mike knew how much Joni loved animals, he took her on an adventure to Temple, Texas where they adopted Haley and Katie, two adorable West Highland Terrier sisters. Sadly, after twelve years of devotion, Haley recently passed away. Her sister Katie is diabetic, among other health problems, but she is still going strong.

Miraculously, after ten years of trying to have a child, Mike and Joni were blessed with their second set of twins, Madison and Matthew. Joni and Mike now had two sets of twins.

"Isn't it interesting how life can repeat itself?" asked Joni.

When asked if the dogs are spoiled, Joni replied with a smile, "Definitely! They sleep in bed with us and travel nearly everywhere we go. They receive carrots for treats and we even buy them silly outfits for their Christmas pictures."

Both Westies were also very empathetic. Joni said, "When I went into labor with the twins, Haley and Katie howled for the first time in their lives. They also howled when I became upset over my daughter's really high temperature. They can obviously tell when I'm truly distressed. Whenever I am sick, they never leave my side. The love they give just touches my heart. All they want in their little lives is to be as close to me as they can."

The dogs definitely have led lives of luxury! Haley and Katie always stayed in bed after Mike and Joni got up in the morning. "They enjoyed listening to the sound machine, so we left the drapes closed, and they would sleep late," laughed Joni.

When asked what made her feel best about her pets, Joni said, "Even in pain near the end of Haley's life, she never growled or nipped at the children. I'm also very proud of how Katie is handling the loss of Haley. They were best friends for their whole lives, and they were completely inseparable. Katie hurts, too, and needs extra hugs, but continues to eat well and be a special part of the family."

As Joni talked about her dogs, she thoughtfully said, "I have a common bond with animal people. We also have play dates with other friends' dogs. They have helped me do things I never thought I could, such as dealing with Katie's diabetes. I would not have believed that I could give daily insulin shots and test Katie's blood, or cook her special food and measure how much she eats. I have grown in so many ways because of their courage and devotion. My dogs have shown me unconditional love their entire lives. Because of them, I can't imagine a life without animals!"

 Q & A

What do you call yourself to your pets? Mommy.

What makes you laugh the most about your pets? When they chase and "play fight" with each other. Also, the fact that they stay in bed after Mike and I get up in the morning.

What's the cutest thing your pets do? _Haley_ didn't like to eat her treats immediately. She would dig an imaginary hole in the middle of the room and try to hide them first before she'd eat them. _Katie_ loves baby squeaky toys, but not dog toys. If our babies are playing with anything that squeaks, Katie pounces and tries to make the toy squeak for herself. **(Haley and Katie pictured right)**

One might expect to see Bucky Buckaroo and Wild Willie to show up in Western regalia, but these white West Highland Terriers prefer fur and their collars to let their personalities speak for themselves. Tandy and Lee Roy Mitchell dote on the boys and have a red barn cat named Leo who acts like he is a dog too.

TANDY & LEE ROY MITCHELL

Bucky Buckaroo, Wild Willie & Kitty

Bucky is ten years old and was purchased from a breeder in Fort Worth, whose business later burned to the ground. Wild Willie, now four years old, has a birthday on September 11 and came from Terrell. Leo, the kitty, is two-and-a-half years old and was found in a barn by Lee Roy's mother.

These pets get what they want, when they want it.

"Willie is so spoiled he stinks and Bucky doesn't show it so much. He waits for it to be given to him," Tandy said. Lee Roy added, "I'm the doorman."

Their treats are all natural and consist of vegetables and fruit. Neither one of the boys seems to care for toys anymore, but they are particular about the people they like. For those who live on the Mitchell's estate, the animals have all chosen their favorite people. Bucky likes to be outside with Jessie, Willie stays inside as Sous Chef with Carmencita, and Leo is attached to Sylvia.

When asked if they would call their pets compassionate, Tandy said, "They sense our moods. When I'm sick, they lie next to me and think they're sick, Bucky much more than Willie." Lee Roy commented, "They're sad when you're sad and happy when you're happy."

These pets are absolutely family members. Jokingly, Tandy said, "The dogs are nicer than the kids most of the time!" With a laugh, Lee Roy said, "The difference between kids and pets is my pets love me all the time." Tandy said it feels good to be around the pets; they are very calming to her. Lee Roy warmly said that what touches his heart is when they hurt and can't tell him what hurts.

"The most important thing I've learned from my pets is the importance of stretching. When a dog wakes up, he always stretches, and at my age that is very important! Also, obedience and loyalty to the ones they love," said Lee Roy. Adding to that, Tandy said, "I'm sure you've heard it before, but unconditional love. No matter what you do to them, they still love you. The world needs to be more like that."

Some of the cutest antics which give Tandy and Lee Roy a good laugh are watching the boys run in perfect synchronization. They play together and chase squirrels. Leo the cat is a pal and will surprise Wild Willie by jumping on his back. When Bucky wants to play, he will stomp on all four feet at once. Lee Roy said, "When I come home after work, Willie will always greet me at the door, I'll lean over and he jumps up and gives me a "wet willie" in the ear!"

In a soft, affectionate voice, Tandy said, "They are my kids. I'm very in-tune with them and everything they do. I instantly know when they are sick or something is not right. I have a sixth sense about them and what they are feeling and need." Lee Roy introspectively said, "They are God's gift to prepare us for life and death. You get them, watch them grow up, get attached, go through their lives, and then through their deaths. It's the cycle to prepare us for our lives."

 Q & A

What do you call yourself to your pets? Mom and Dad

Do you feel that your pets can talk to you? Yes, through their mannerisms. Willie will take you to the cabinet and keep staring at the door. You can open another cabinet door but he won't take his eyes off the cabinet door with the treats in them. When we spell "Greenies," both Bucky and Willie know the word, even if we spell it out!

What makes you feel best about your pets? When they are really feeling good, playing and running.

Have your pets help you make a new circle of friends? Not really, but many of our friends have gotten Westies because of our dogs. Bucky and Willie are very well-behaved and don't jump on people.

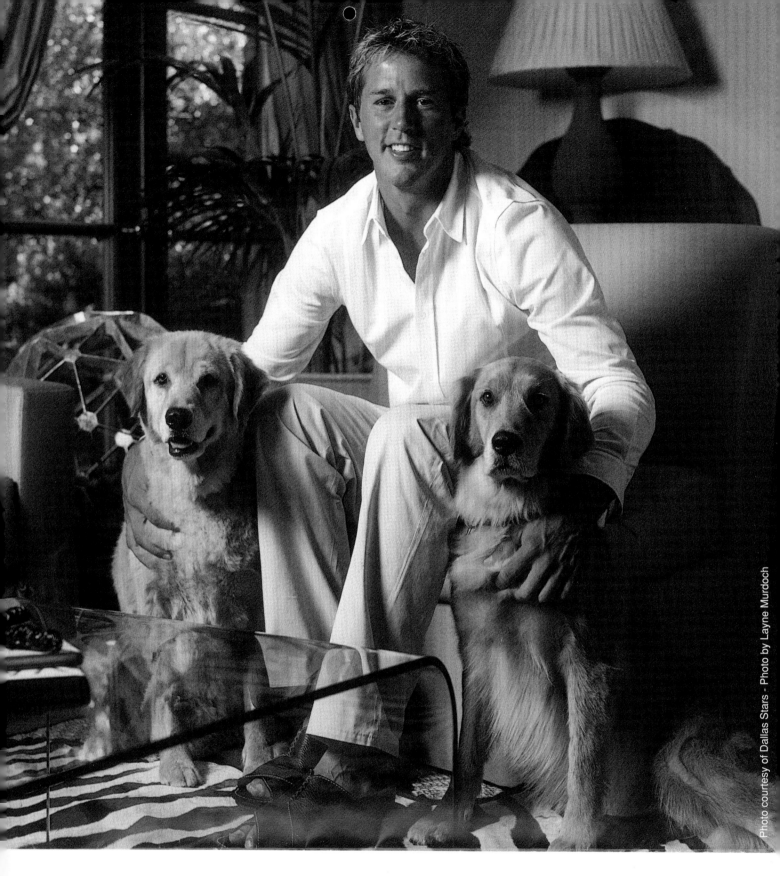

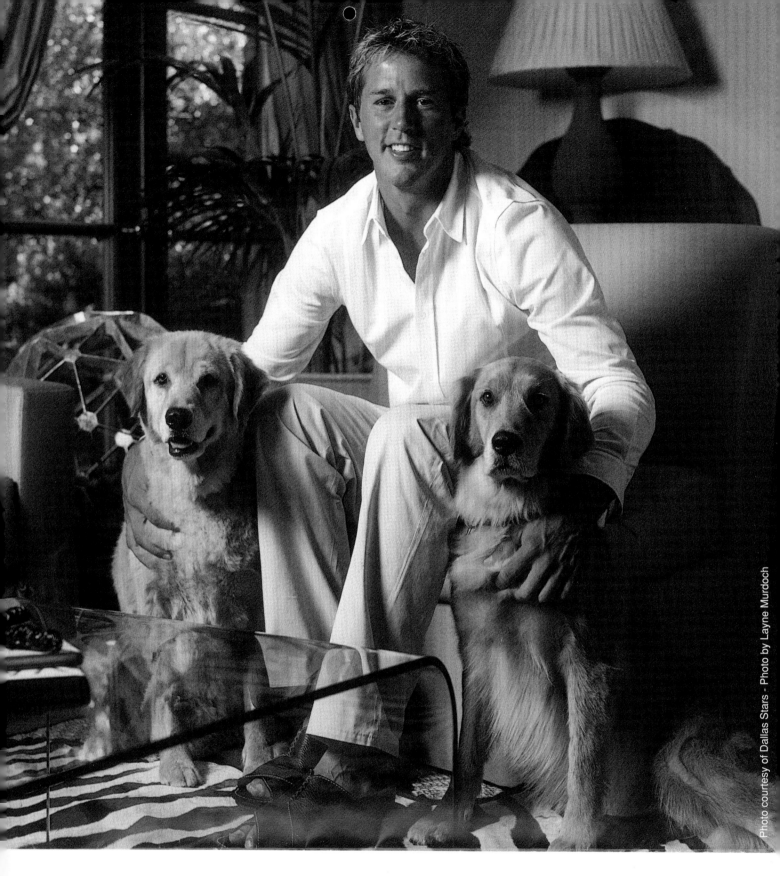

Photo courtesy of Dallas Stars - Photo by Layne Murdoch

Mike Modano is Center and Captain for the Dallas Stars hockey team. He has been a member since 1988 and is a six-time NHL All Star. He holds the franchise record for career goals and assists and total career points. He helped lead the Stars to win the Stanley Cup, the most coveted trophy in professional sports, during the 1998-99 Season.

MIKE MODANO

Bella & Scout

When he's not busy scoring points for the team he enjoys spending time with his pets, Golden Retrievers, Bella and Scout. The dogs are known for their friendly, reliable and trustworthy natures. His dogs are a great source of comfort to him and sleep in his room. Mike is impressed with their different personalities. Bella is a morning dog and gets up with the sun while Scout prefers to sleep until noon each day.

Mike said, "The dogs are compassionate and somewhat spoiled. Usually, when I see a treat that I know they like, I get it for them. They are so loving and giving that they deserve to be treated well."

While Mike is committed to his sport, his country and his team, he is equally passionate about his personal responsibility to give back to his local community. He has given time and energy to many organizations throughout his career. One of his personal goals was to build something lasting, and in 2000 he established the Mike Modano Foundation.

The Mike Modano Foundation's mission is to raise funds to improve the quality of life for at-risk and under-served children in the Dallas, Texas area. The primary focus of the foundation is to serve children who have been abused (either physically, emotionally or both), abandoned or neglected. In addition, the Mike Modano Foundation provides funding for organizations whose purpose is to offer education to children and families suffering the devastation of abuse to help break the cycle of abuse.

Mike is involved with several other nonprofit organizations and has been a friend to the SPCA of Texas for many years. Mike and several teammates appeared in the 2004 team's Pet Calendar to benefit the SPCA. Mike won the award for the category of people who most resemble their pets because he and Scout are both golden boys!

Mike said, "My life has been blessed in so many ways. I believe that I have an obligation to share my good fortune and try to make a difference in the lives of others. As a public figure, I also have a rare opportunity to speak out and be heard."

Q & A

Would you call your pet compassionate? Yes.

How often do you buy your pets something? Usually when I see a treat that I know they like, I get it for them.

What are your pets' personalities like? Bella is a morning dog and gets up with the sun while Scout prefers to sleep until noon each day.

What touches your heart the most about your pet? Their unconditional love and their kisses.

After Tonda Montague's Cocker Spaniel passed away, she began searching for a new four-legged friend. Her research through the *Dog Book Encyclopedia* and dog magazines led her to select a Coton de Tulear, a rare breed from Madagascar that is part of the Bichon family with a long cotton-like coat.

TONDA MONTAGUE

& Marley

When asked if Marley, her Coton de Tulear, is spoiled, Tonda replied, "Absolutely! He gets treats every time I travel. Working for Southwest Airlines, I travel a lot so Marley gets lots of treats! He likes to go through my suitcase looking to see what I brought him when I return from a trip. He even does this to my guests."

Tonda is "Mommy" to Marley. The pup also enjoys the company of Tonda's brother, Kyle, and her neighbor, Suzy. Marley is very friendly and loves to wear his University of Texas bandana when Tonda and her friends are watching Texas Longhorns football games. He also has a devil costume for Halloween, and his girlfriend Chanel wears an angel costume.

Chanel is a special friend who lived across the street from Tonda and Marley. According to Tonda, "The dogs fell in love at first sight. After a few weeks, Marley would lie on a bench by the front window, waiting to see his friend. Even though Tonda has since moved, Chanel and Marley still spend every week day together and enjoy watching Animal Planet at home while their parents work."

In addition to having the run of the house during the day, Marley also likes to lie on top of a table or desk while Tonda reads the newspaper or works. Tonda laughed and said, "It's so cute; he's really an in-your-face type of guy!"

When asked how Marley has touched her heart the most, Tonda smiled and said, "Several years ago my mom had a stroke and was in a nursing home for two years before she passed away. Marley went on many, many visits to see her. Marley was so sweet and loving to everyone at the home. He would lie with Mom in her bed while we watched TV and visited. He also made a friend across the hallway, Billy. I think they shared a few meals."

Tonda continued, "Marley shows such unconditional love. When I get home, he jumps as high as he can because he's so happy I'm home. And, of course, I learned from Marley, during our visits to the nursing home, that it's important to slow down a little and visit with the elderly. It means so much to them to have some extra attention."

Q & A

How often do you buy your pet something? Every single time I travel. When I return home and start unpacking my bag, he assumes the begging position because he knows I have a treat. He's actually started doing this to all of my house guests when they open their suitcases. Working for an airline, I travel a lot and have lots of guests. So, Marley gets lots of treats!

Do you dress up your pet? Marley has a University of Texas bandana that he wears when we're watching a Texas Longhorns football game. He has a devil costume for Halloween, and his girlfriend Chanel wears an angel costume. We greet our trick-or-treaters this way.

Do you feel your pet has touched your soul in some way? I have a sign that was given to me by Colleen Barrett, the President of Southwest Airlines. It says, "The high point of my day is when I get home to be with my dog." Marley seems to be such a calming force when I arrive home from a hectic day at work. It relaxes me to take him for a walk.

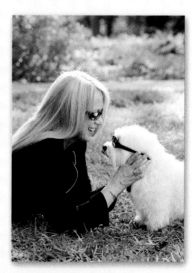

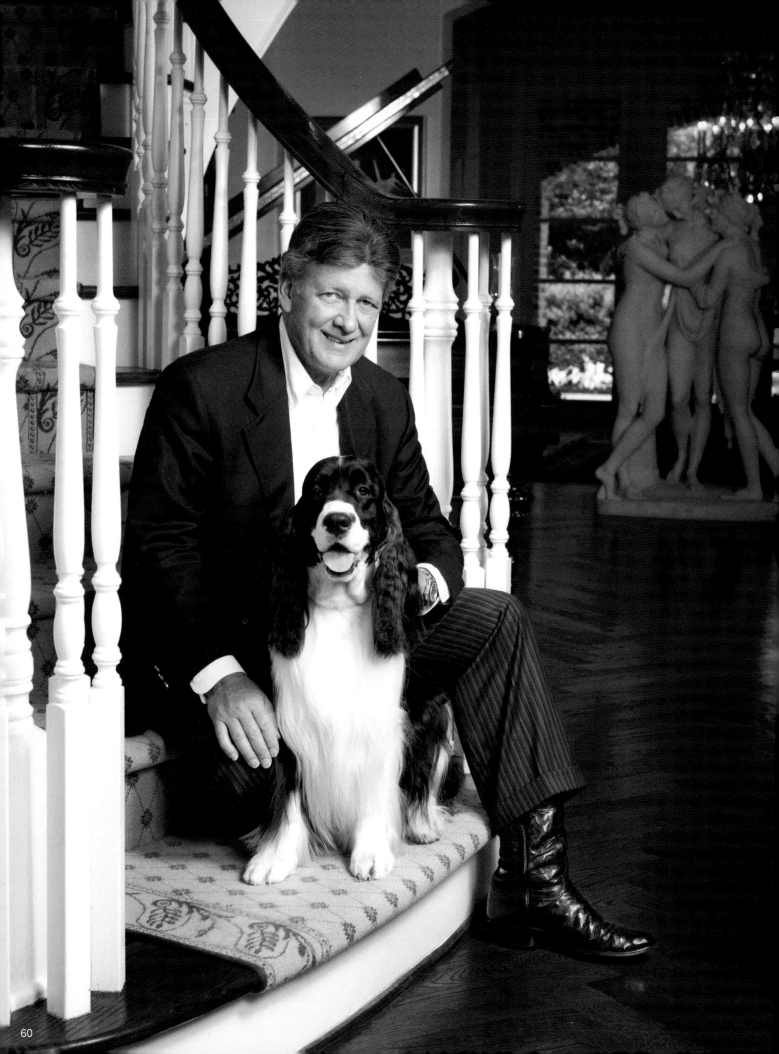

SHARON & WILLIAM MORRIS

& Sir Spencer

The Mutual Admiration Society is alive and well at the home of Sharon and William Morris with their English Springer Spaniel.

Sir Spencer is a gorgeous black and white five-year-old male who is full of life and very dedicated to his family.

English Springer Spaniels are medium-sized sporting/hunting dogs with great personalities and lots of energy. They are predecessors of the Cocker Spaniels of today. Their history spans centuries and dates back to the Roman Empire.

Like his ancestors, Sir Spencer is a squirrel hunter par excellence. He leaves the bird retrieving to others whose coats are not as well groomed as his. Burrs and twigs just don't fit his routine. Spencer's favorite hunting retreat is Lake McQueeney where he enjoys the duck scramble, squirrel run and midnight nutria chases. According to Sharon, "It's odd to see this loving, sweetheart, beautiful canine tear out like a normal dog. We always thought he was a little boy in a dog suit."

Sharon said they love to take Spencer along when possible, as he loves to be included in everything. Sharon said, "We walk every day in our neighborhood and greet neighbors of all ages and their pets. Occasionally, there is impromptu play time. It's so much fun to watch these pets react in the group." Sharon smiled, "Since our children have moved out, Spencer has become our social director."

Spencer's mother, Cara, won the Dam of the Year 2004 from the National English Springer Spaniel Club because so many of her children finished their points and are champions now. Spencer's father, Storm Warning, has won the Canadian and American Sire of the Year awards multiple times. Sharon said, "Sir Spencer is a chip off the two blocks!"

Treats are an everyday happening with Spencer. Sharon said, "He absolutely loves fruits and veggies. Grapes, apples, pears, broccoli, asparagus and green beans are some of his favorites. Then if he responds properly to commands, there are always hugs and kisses with packaged doggie cookies. After our long walks, especially in the heat of summer, Spencer's favorite treat is a swim in the back yard pool."

 Q & A

Has your pet helped you develop a new circle of friends? Definitely!!! When you walk your dog, greeting neighbors goes along with it. The children love to pet him and throw balls for him to retrieve.

Has your pet touched your heart? Yes!! He has taught us unconditional love.

Why did you select this type of pet? English Springer Spaniels are so full of life. They are very active dogs.

What makes you feel best about your pet? He's just so human. He is truly a member of the family.

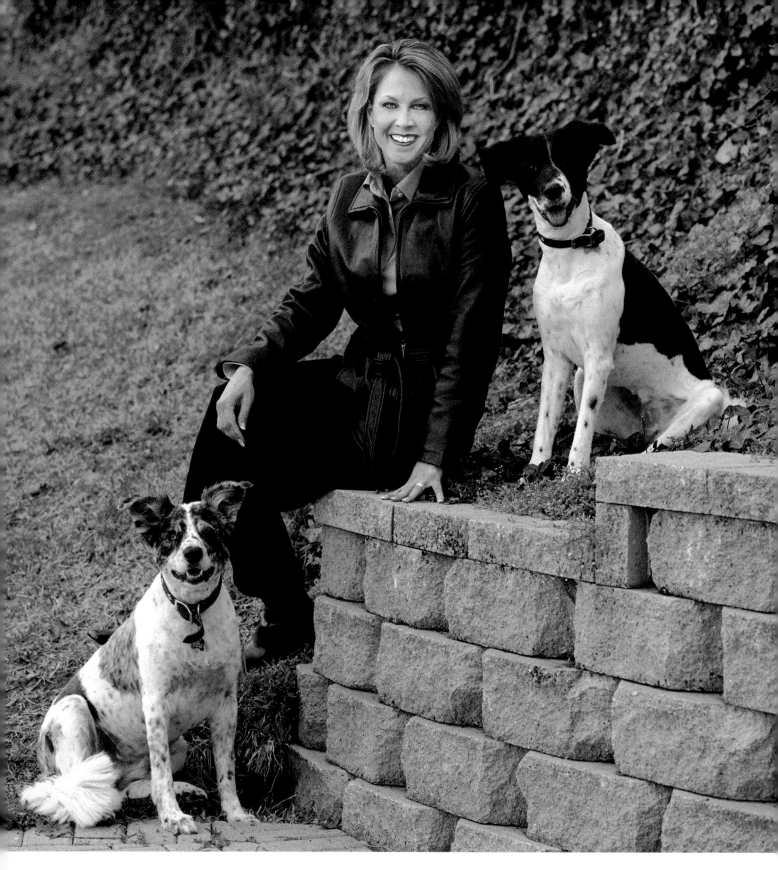

Animals have always been April Prohaska's true love. After leaving the corporate world in December of 2000, she opened Paws Pet Services in early 2001 because she recognized the need for reliable in-home pet services at an affordable price.

APRIL PROHASKA

Blue, Bear, Riley & Dakota

As a pet owner, she understands the relationships and bonds people share with their pets and the importance of providing quality, dependable in-home pet care. Now with more than six hundred clients and a total of six staff members, her dream business idea has come true. On top of that, through the years she seems to have become a magnet for stray and injured pets. She has rescued and placed more than fifteen hundred animals through her vast network.

At April's home, guests are greeted with lots of kisses and made to feel very welcome by her four-footed companions. April rescued Blue, a beautiful, calm and loving Australian Shepherd, with one blue eye and one brown, from the SPCA of Texas in Dallas eight years ago. Blue was the first dog April got as her very own. Several years ago she adopted Bear, a Border Collie, from the SPCA, who doesn't know a stranger and is quite the social butterfly and a gentle soul.

April also has two cats, an eight-year-old gray tabby, Riley, who she rescued from a veterinary clinic, and her newest addition, Dakota, a young calico kitten who demands attention and loves to snuggle.

Her pets have helped April make a new circle of friends. Laughed April, "My pets are very social and well-mannered. When we go to the dog park, we meet people constantly. I play co-ed football on Saturdays and Blue goes with me. She is a Frisbee® dog and will play Frisbee® with anyone who will throw it for her."

Blue and Bear also accompany April to work every day at her other business, The Pooch Patio on Fairmont in the Oak Lawn area of Dallas. This wine and beer bistro, java bar, doggie daycare, pet boutique and self-serve grooming business is a hopping place to hang out for patrons and their pets. Bear and Blue are the managers on duty and have become an integral part of the atmosphere.

According to April, "I laugh the most at how they vie for my attention. In the evening, they tell me when it is time to go to bed. Bear will herd me in to the bedroom, and they'll both jump on the bed and curl up to go to sleep. Of course, they are both bed hogs!"
When asked what makes her feel best about her pets, April said, "I know what a wonderful life I am providing for my four-legged companions. They are true members of my family."

April said, "I've recognized through my work with animals that they are unconditional, loving souls who constantly teach me lessons on compassion, generosity and love. On a daily basis, they help me to be a more loving person. They constantly give of themselves and they prove to me every day what sweet souls they truly are. I love to try and emulate their nature in every way I can."

 Q & A

What's the most important thing you've learned from your pets? Unconditional love and companionship.

How often do you buy your pets something? Every day I get them a bagel biscuit or bones, and they are given toys and natural treats regularly.

Would you say your pets are spoiled? They are very spoiled. Bear and Blue get ball-time, walks, and rides in the car once a week. Shoot, they both go to work with me! They eat Paul's Pet Food, a natural food made in Lewisville and a Juice Plus supplement added to their food, as well as multi-vitamins every day.

Where do your pets sleep? In bed with me of course!.

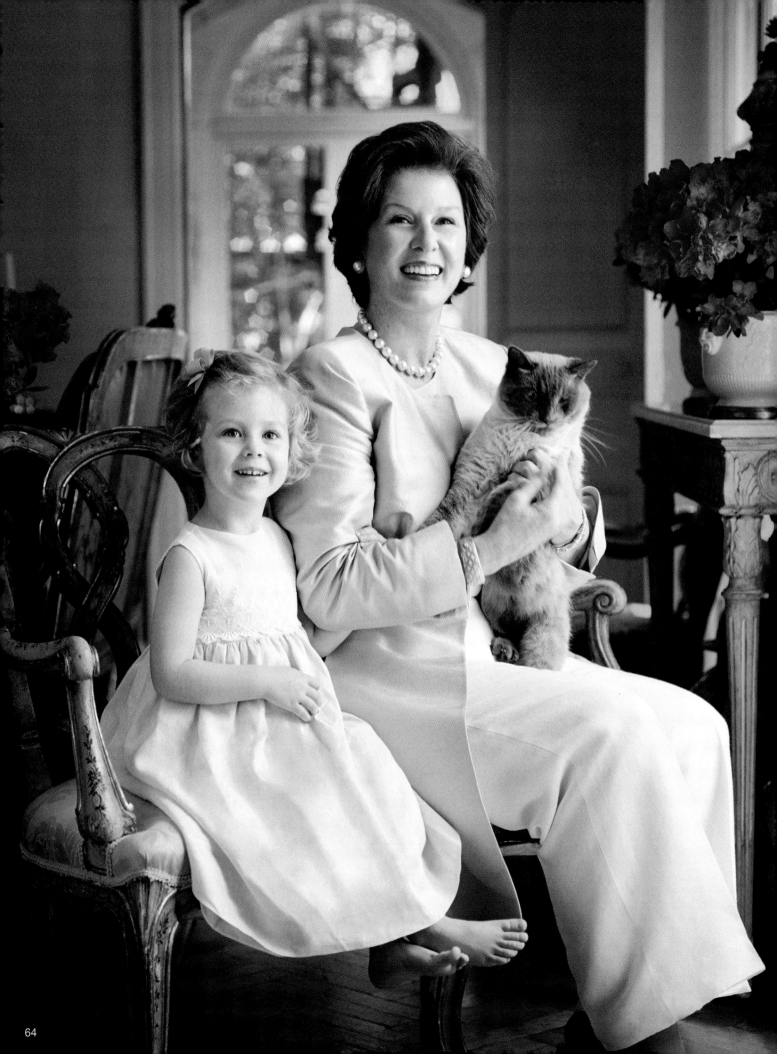

GAY & CAROLINE RATLIFF

& Fernando

Gay Ratliff has loved animals as long as she can remember. Her family always had dogs, cats and horses growing up, and all have left lasting impressions.

About four years ago, while at work at her business as an Interior Designer, Gay's primary upholsterer mentioned to her that he had a litter of five homeless Siamese-mixed kittens that he would be taking to a shelter. Gay fell in love with the brood and declared that the cats would not be going to a shelter; she would help them find homes personally.

Gay found good homes for three of the cats and kept the other two, Fernando and Gabriella.

Fernando, the more adventuresome of the pair, is also known as "Nandi" to Gay's granddaughter, Caroline. He has a light gray-and-cream-colored coat with blue eyes and resembles a Panda Bear. He actually talks and loves to jump in the shower. He loves to chase butterflies and will leap into the air after them all the time.

His sister, Gabriella, is demure and ladylike and is nicknamed "Gabby."

Gay's third cat, Sterling, a gray-striped tabby, was an anniversary present from her children about sixteen years ago. His nickname is "Sterling Silver" because he was given to her on her silver wedding anniversary. All of Gay's pets are very trusting and loving with sweet dispositions. They are entertaining, and just like people, have very unique personalities.

"They are just like little children," said Gay. "They love unconditionally and are always happy to see me."

Gay fondly remembers Coco Chanel, a beautiful Persian cat that her daughter found in a parking lot. She had white gloves and was a perfect little lady. Coco passed away at a ripe old age during the summer of 2005. Gay smiles and remembers another pet from a long time ago, named Big Foot Wallace.

"My dad named Big Foot after a Texas Cowboy character. Big Foot had an extra digit on each foot and was very sweet but also very mischievous and comical. Laying on his back with his head hanging off a chair and looking at you upside down was one of his favorite pastimes."

Q & A

Where do your pets sleep? Just like people, they all sleep in beds. Fernando sleeps on his back with his feet in the air.

What touches you the most about your pets? They are really part of the family.

Do you feel as if your pets can talk with you? Definitely! Fernando can carry on a full-fledged conversation, and will tell anyone exactly what he wants.

J an Richey's and Tom Lamphere's seven-year-old Shiba Inu guard dog, Sadi, originally bred as a national Japanese treasure, is the first one to greet you at their home. Small in stature but big on personality, Sadi protects the property but makes guests feel very welcome once they have been "approved" by Mom and Dad.

Jan Richey & Tom Lamphere

Sadi Sue, Bugsy, Scooter, Annie & Trapper

Scooter, a black cat, likes to sit on a bar stool with his paws thrown over the back of the chair, and he enjoys a good conversation. He loves toys and stays close to Tom at all times. In the theater room you'll actually find them watching movies together. "Scooter is quite attentive," chuckled Tom. His vocabulary is quite extensive and when Tom asks, Scooter will fetch toys for playtime! As a small kitten, he was rescued at Cedar Creek Lake and has been a featured "Star" in the Cedar Creek Friends of The Family Calendar ever since.

Annie and Trapper are also rescue animals. They are mother and daughter cats that Jan trapped in the dead of winter before they froze, or starved to death. They were named appropriately: Annie after Little Orphan Annie, and Trapper because Jan had to trap 'er. Jan calls Annie, her tortoise shell kitty, her "soul sister." She is quite the princess, as she sleeps on Jan's pillow every night. Tom has finally gotten used to turning over in bed and getting a face full of cat fur. Trapper is a bit shy when company is around but is very fun and playful when Mommy and Daddy are the only ones home.

For a real look into this family, the treat extravaganzas are ones to watch. In the mornings when Tom turns on his razor (better known as the food machine), Sadi will bark and wait for a handful of cat food. She distinguishes between the sound of the electric toothbrush and razor, knowing which one will let her "work" Daddy for some vittles! In the evenings the three cats line up on the bar as Tom expediently opens a can of cat food. The cats eat the gravy, as the dogs wait patiently. When Scooter, Annie and Trapper are finished, Sadi and Bugsy get the leftovers as their evening hors d'oeuvres.

When asked if the pets ever comfort them, Jan said, "Annie and Trapper are very compassionate with me and stay close." Tom said, "Sadi and Trapper comfort me all the time. They give concerned looks when they see me upset or sad. They both definitely sense my moods and will lay by my feet. With Bugsy, it's all about him, so he doesn't give much comfort. He just asks for it from everyone else!"

Both Tom and Jan feel that their animals are their kindred spirits. They commented that as far as their "fur children" are concerned, Tom's and Jan's only purpose in life is to feed, love on, provide shelter for and be very quiet while they nap. "We are just their puppets," laughs Tom, "and that is fine with us!"

Q & A

What makes you feel best about your pet? "Sadi and Bugsy like to walk with me and LOVE to ride in the car.

Do you feel as if your pet can talk to you? Scooter does especially, because he is very vocal and uses a variety of sounds.

Do you ever dress up your pet? The cats get sweaters, and occasionally, we put scarves on the dogs.

What do you call yourself to your pets? Mommy and Daddy – the pets are The Kids!

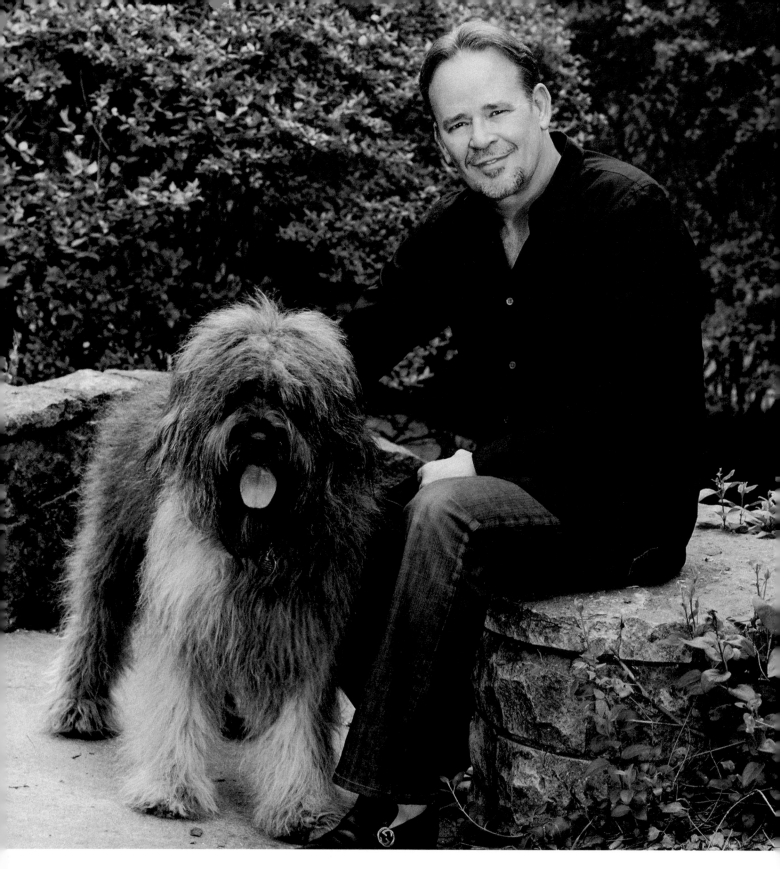

Not every dog arrives with his own curriculum vitae, but El Oso de Monte Carlo (The Bear of Monte Carlo), better known as Carlo, was happy to present his.

ROYCE RING

& Carlo

Carlo's best friend, Royce Ring, had seen a Bouvier de Flanders several years ago and began researching the breed. After an extensive eight month worldwide search, he found a litter of brindle pups in Phoenix, Arizona. He and his son made an epic cross-country road trip to bring Carlo to Dallas.

Smiled Royce, "Carlo is such a part of my life. We have such a bond; I can't imagine not being with him. He is my true companion."

Carlo had much more to say than Royce. Without any interruptions, Carlo gave quite an interview, saying, "I come from a rich long tradition of flock guardians. Many of my cousins are in service as police dogs in Brussels and Paris. I am not related to Jacqueline Bouvier Kennedy Onassis; however, I have a distant cousin currently performing in a Russian circus."

Continued Carlo, "I can run a 4.43 second forty-yard dash and can clear a one meter hedge or wall in a single bound. At seventy-seven pounds, I can be formidable or a cuddly bear. Don't tell anyone, but I have one glaring weakness, I cannot read, after all, I am a dog. I listen to percussion and down-beat dog tunes and, am known to be an occasional participant in late night drum circles.

"My mission in life is to travel the neighborhoods in search of people who ask Royce if I am an Old English Sheepdog, Briard, Russian Ovcharka, monkey, small bear or pygmy goat. It seems everyone wants to touch my fur and find out if I really have eyes.

"Sniffing, trick rehearsals, keeping the neighborhood safe, entertaining, and searching the skies for pigeons and small aircrafts are just a few of my hobbies. You can find me hanging out at Starbucks in West Village and Lee Harvey's on Sunday Dog-Day Afternoons. I drink champagne, of course, but only on special occasions. Texas Cowboy bone-in rib eye is my favorite meal, however, to keep my trim figure, Royce has placed me on a diet of traditional dry kibble.

"A workday for me is 16-18 hours of sleep at the work-station at home, with several walks, and the occasional shakedown of Fed-Ex delivery drivers. For a pound of treats, I can learn any trick in two days. My repertoire of acts includes sit, stay, come, heel, shake, wait, catch, fetch, jump, roll-over, dance and kiss. Otherwise, you can find me rearranging the fur on my stuffed rabbit, duck, quail or dinosaur. I surgically removed the squeakers on each of them. I also have quite an array of bones.

"My best friend, mentor, and source of meals, drinks and entertainment is Royce. He is lucky to have me, and I am the luckiest dog in the world."

Royce agreed saying, "He is the loyal personification of unconditional love. He's just there; never judgmental or cross with you, and completely loyal in a pure way. Carlo is the manifestation of a dream and search. It's actually very serendipitous ... dreams can be realized."

Q & A

Has your pet helped you make a new circle of friends? I am constantly stopped and asked what kind of animal Carlo is by strangers. A handful of these people have actually become friends.

Has your pet ever comforted you? Being around him is a real source of joy.

What makes you laugh the most about your pet? When he is really anxious for a treat, he will do all of his tricks in one single motion.

Carlo, what makes you most anxious about your best friend? That he may enter me in a Dog Poker Tournament and I'll suffer the ridicule of having my portrait done, while playing cards, with random dogs dressed in street clothes.

O n any given day at the Romano estate, one may see the Bayou cousins, Golden Retrievers Hank and
Honey, surveying the property, playing with tennis balls or Honey fishing in the pond. One might also
catch a glimpse of PJ, a golden Labrador Retriever, riding shotgun with house manager Rohelio on a
golf cart.

LILLIE, PHIL & SAM ROMANO

Gotee, Yoshi, Hank, Honey & PJ

Gotee, a black-and-white tuxedo cat, usually lays around on his back with the Romano's son, Sam. Gotee sits next to Sam in this peculiar position and seems to think he is human. Yoshi, the other cat, is a little bit more reclusive when company is around.

Welcome to a pet-friendly family. Lillie was raised with hunting dogs, and Philip had dogs all his life. Sam has been raised with a variety of animals since he was in pre-school.

Each animal has its own unique personality and place in the family. Lillie's father bought four-year-old Hank and Honey in Louisiana as a gift. One-year-old PJ was initially intended to be a donated puppy for a Scottish Rite Hospital benefit, but Philip fell in love with the puppy, and they returned to the litter and chose another puppy to donate to the auction. Lillie thought PJ looked like Mr. Philip James Romano, hence the name PJ.

Four years ago, the family took a trip to Colleyville and adopted Yoshi, a conch-shell calico cat who jumped on to the cage door and would not get down. Last year, on one of Lillie's Hunger Buster routes, a homeless man was carrying a three-week-old kitten. Lillie took the orphaned ball of fur, nursed and nurtured her, and today Gotee is a year old and doesn't know a stranger.

Lillie said, "We may be firm on their diet, but the dogs have their own air-conditioned and heated dog runs in the garage with a pet door. We even dress them up at Halloween."

When asked what touches their hearts the most about the pets, Lillie quickly and thoughtfully said, "Every day I find them completely therapeutic. We walk the property and enjoy the time together. Their beauty just takes my breath away."

Philip strongly agreed, "Honey is the smartest and most athletic. She will act like a bear and actually catch fish in the pond." He continued, "We do have to bring the dogs inside when the tennis team comes over or Hank and Honey would take possession of all the balls."

When asked what the most important thing is they have learned from their pets, Lillie said, "Unconditional love." Philip thought for a moment, then said, "They can be mad for a moment, like when we first come home from vacation, but then they move on and let it go. You start to play with them and it's all forgotten." Lillie added, "Most of the time, they are just overjoyed to see us and we are pleased to have them all in our lives."

 Q & A

What do you feed your pets? Even though good food is synonymous with the Romano name, these pets are kept on a strict diet and treats are not a part of the eating regimen. Good veterinary care and a proper diet keep these animals healthy, trim and fit.

What do you call yourself to your pets? Mom, Dad, and Sam is big brother.

What's the cutest thing your pets do? Seeing Gotee laying around on his back all the time. Yoshi used to climb up pants legs. PJ will race inside to see if there is any cat food left on the floor. Hank just wants to play ball, "give me the ball, give me the ball!"

Do you feel that your pets can talk to you? Definitely! They let us know "I'm hungry, I'm tired, I want to exercise, what are you doing, I live for tennis balls!"

Have your pets ever comforted you? All the time, ever yday! We walk the property and it is so therapeutic.

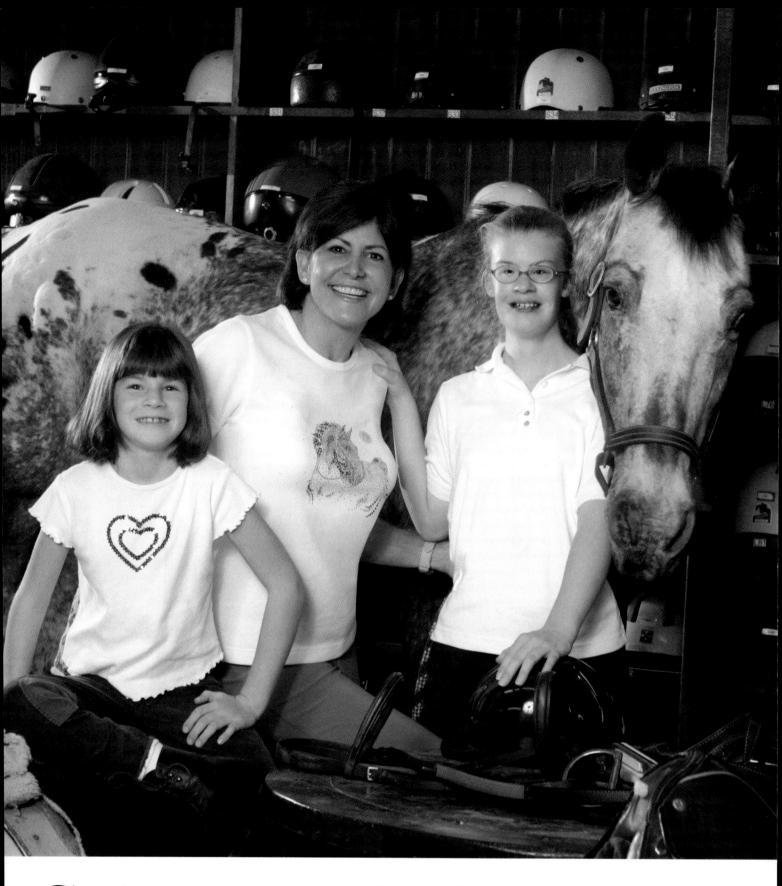

Susan Schwartz is the co-founder of Equest Therapeutic Horsemanship, an internationally recognized nonprofit organization that provides equine assisted therapy for children and adults with all types of disabilities and learning differences. Combining horses and humans has proven to be a very effective form of therapy, benefiting the clients physically, cognitively, emotionally and socially.

SUSAN SCHWARTZ

& the Equest Horses

Susan has been a lifelong rider and horse lover, as well as a teacher for students with learning differences. In 1981, she decided to combine her two loves, teaching and horses, to create a program which enables people, regardless of their physical or cognitive challenges, to benefit from therapy only horses can provide.

Susan's vision, coupled with superb instructors, staff, volunteers, and a dedicated Board of Directors, helped Equest become one of the premier riding centers in the country. Equest offers services in Hippotherapy, Therapeutic Sports Riding, Therapeutic Carriage Driving and Therapeutic Riding Instructor Training. In 1988, Susan helped raise funds to purchase a facility on the shores of Lake Ray Hubbard, which became Equest's home. In 2004, Susan won the North American Riding for the Handicapped Association's prestigious National Volunteer of the Year award. According to Susan, "The Equest horses are the real heroes of the program! They help over two hundred riders each week. Many horses at Equest are donated and all are very carefully screened before entering the program. They must pass strict guidelines and be sound, unflappable, and healthy to be accepted."

Susan continued, "The horses are a source of hope for people with disabilities. New abilities, self discipline, and improved concentration build self-confidence. With confidence, self-esteem and quality of life are enhanced."

For riders who have the desire, Equest offers competition opportunities including Special Olympics, Paralympic selection shows, American Quarter Horse Association Classes for Riders with Disabilities, as well as open and able-bodied shows. Many riders at Equest compete at local, regional, national or international competitions.

Deb Lewin is one of many Equest success stories. Deb suffered a traumatic brain injury in an auto accident in 1996, is paralyzed on her left side, and suffers from visual and neurological complications. She began riding at Equest in 1997 and after a few riding lessons, her family and friends noticed the difference in her physical, mental, emotional and spiritual states. Her balance and strength was much improved and her self confidence skyrocketed. Her neurosurgeon was amazed! Deb soon began competing in horse shows for riders with disabilities and currently is ranked second in the country for elite riders with disabilities.

Susan deeply believes that it is the unique bond formed between the rider and horse that creates the miracle each day at Equest. Because horseback riding improves posture, balance and muscle control, many clients begin walking in spite of doctors' prognoses. Clients will claim that riding enabled them to walk. Clearly, at Equest, miracles are possible!

Q & A

What is Equest Therapeutic Horsemanship? Equest is an internationally recognized nonprofit organization that provides therapy with horses for children and adults with all types of physical, mental and emotional disabilities as well as learning differences.

What are the benefits of Equine Facilitated Therapy? Physical, cognitive, emotional and social skills are all enhanced.

What services are offered at Equest? Hippotherapy, Therapeutic Sports Riding, Therapeutic Carriage Driving and Therapeutic Riding Instructor Training Course programs are available.

Does Equest need volunteers? Volunteers are always needed to assist in riding classes and Hippotherapy sessions. Volunteers are side-walkers or leaders for the students during supervised lessons, assist with mounting and dismounting, and also groom and tack horses. All volunteers must go through mandatory training. People interested in volunteering may call 972-412-1099 or visit the web site at www.equest.org

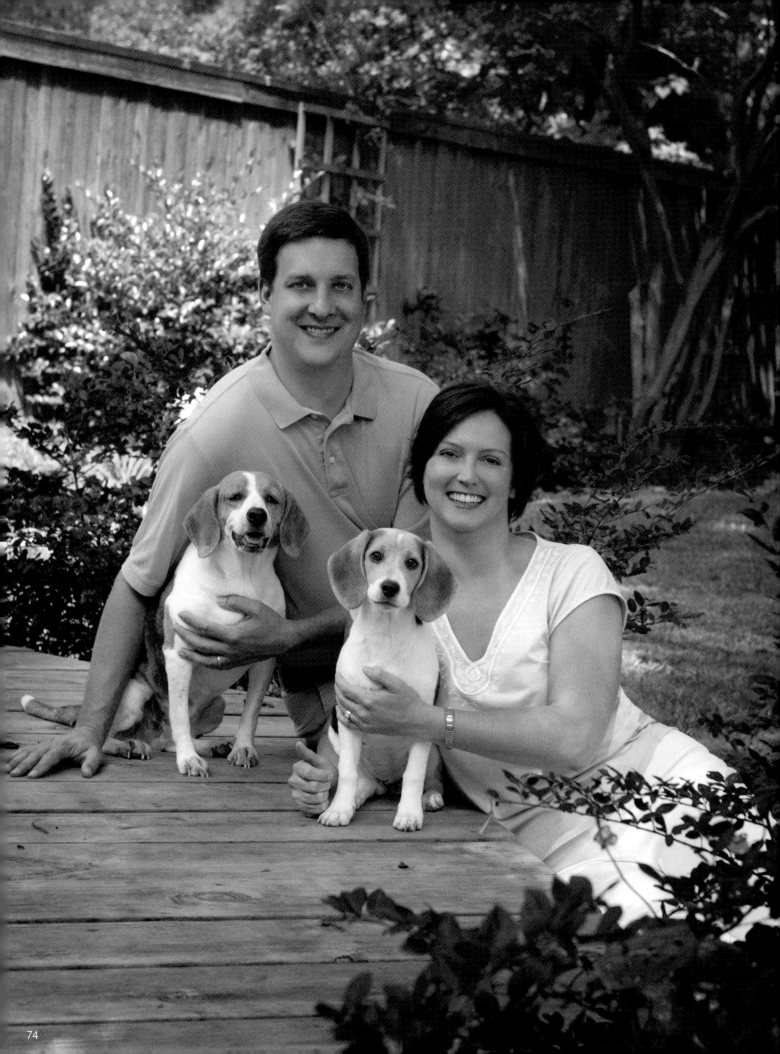

JENNIFER & GREG SELZER

Annie & Daisy

If a person were a dog, would it be great to imagine being fed all-natural, freshly baked treats every day? Well, two friendly Beagles named Annie and Daisy get lots of goodies and join their companions, Jennifer and Greg Selzer, each day at their business, Big Bark Bakery.

Annie is the queen at twelve years old, and Daisy was adopted from the SPCA of Texas and is now almost a year old. Recently, Jennifer and Greg lost their beloved Beagle, Frankie, to canine lymphoma. Frankie was the compassionate cuddler and comforting soul that the Selzers still talk about with tears and soft voices.

Big Bark Bakery was conceptualized more than ten years ago because of Annie. She has allergies and required all-natural foods. The Selzers quietly received recipes and baked homemade meals for their dogs, and eventually began sharing treats with neighbors and family. They soon discovered that there was a real void in the market and left their corporate jobs and began their Dallas business.

When asked what made them laugh the most about Annie and Daisy, Jennifer said, "Watching Annie 'get a hair every now and then' on a blue moon and run around playing like a puppy. She'll also push her water bowl around when it's empty, day or night. With Daisy, it's just watching her be a puppy."

Greg laughed and added, "Annie snores; it's also hilarious to see her get up after sleeping because her face is scrunched up on one side and her teeth are showing! Our favorite thing is sleeping with them, especially taking a nap on Sunday afternoons. We call it a 'Beagle-sam,' (Beagle sandwich)," said Jennifer, "You know, Beagle-person-Beagle."

Jennifer continued, "They are an ingrained part of our family and always understand what is happening. They wag their tails and curl up next to us and it is comforting just to stroke them. They bring such energy and spirit into the house; I can't imagine being without that. What touches my heart most is their companionship, how they just care about us. They comfort and teach us to live in the moment and help us stay grounded. Losing Frankie left a void, a hole in my heart. I still expect to see Frankie at the back door or hear her. You get in rhythms and habits with your pets."

While deep in thought, Greg said, "The most important thing I've learned from them is that, it's not as bad as you think. It never is; life goes on." Jennifer agreed and said, "It's never as big a deal as you think it is." Then with a big laugh, she said, "They've also taught us that cookies make everything better!"

Q & A

Would you call your pet compassionate? Frankie was, but Annie is the diva, who thinks the world belongs to her!

How often do you buy your pet something? At least once a month.

Do you feel as if your pet can talk to you? Without a doubt; Annie communicates through her expressions.

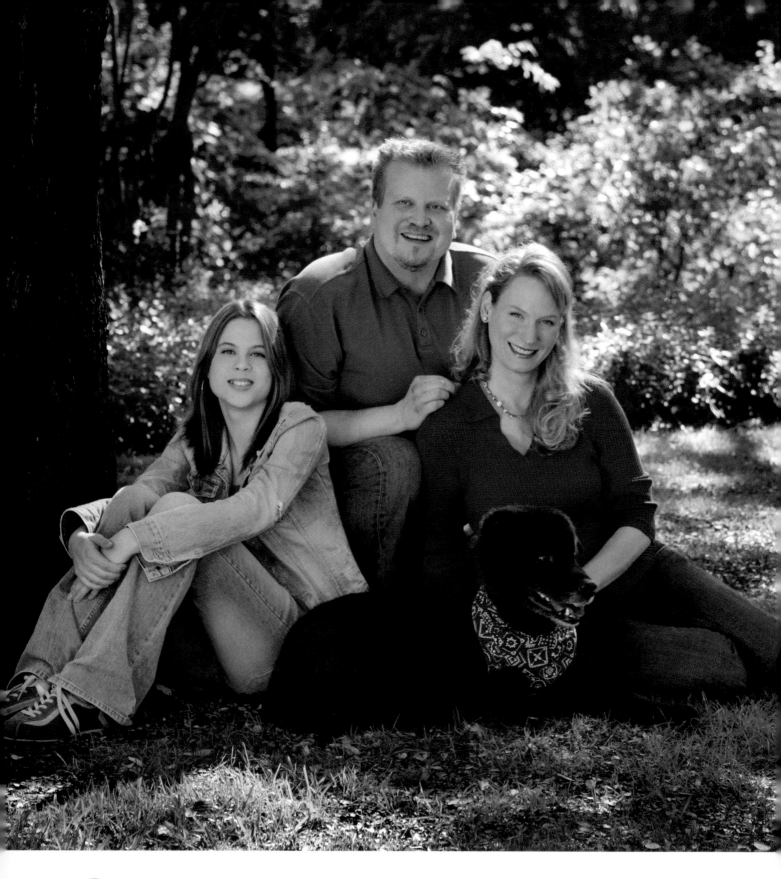

G rizzly Setser is the perfect dog, according to Karla Setser. He is a loving part of the Setser household and protects the family from squirrels, cats and the occasional delivery person.

Karla, Dallas & Jamie Setser

& Grizzly

Karla said, "I could never have asked for a better four-legged companion. He has been my friend, protector and sweetheart for many years."

Grizzly is a Black Labrador/Chow, 65-pound, authentic SPCA mix, who looks like a Labrador when he is shaved and like a Chow Chow when his hair is grown out. He's a big dog but he loves children.

Grizzly has lots of friends. A group of neighborhood girls will ring the door bell several times a week and ask if Grizzly can come out and play. He races through the yard, darting between the children, and acquiesces when they want to give him a high-five or pet him.

Grizzly knew he had made a good choice when he chose to live with Karla. She was single and needed a big dog for safety in Houston. She went to the Houston SPCA about twenty times before she met Grizzly.

Karla said, "Grizzly sat there on the cold, hard concrete and just licked the cage. He asked me to take him home and I told him I had to think about it. When I went home that evening, I couldn't stop thinking about his sweet disposition."

Karla thought she should go home and think about it and if Grizzly was still there the next day, then it was truly meant to be. Karla's sister, Kathy Boulte, who worked at the Houston SPCA, advised Karla that Grizzly had been there for a while and might not be around much longer.

Karla just couldn't let anything happen to Grizzly so she went back and adopted him the next day. The rest is history.

Grizzly liked Karla's husband (or friend at the time), Dallas, right from the start. Grizzly is protective of Karla around most men, but he went right up and licked Dallas on the face when they first met. According to Karla, Dallas went on to teach Grizzly to give "hugs," which is really called jumping on people.

In addition to Dallas, Grizzly loves his "Sissy," Jamie Setser. When Grizzly met Jamie, she was a little girl and he was much bigger than her. Jamie is now a teenager twice his size but he doesn't care, there is more to love. He looks forward to seeing her and they play together as a brother and sister should.

When interviewed for this feature, Grizzly said he loves the SPCA of Texas and hopes that other dogs will pick nice owners like he did. He said to give them lots of licks and kisses on his behalf too.

Q & A

What are your pet's favorite treats? Grizzly loves Bacon Wraps, hard chews, squeaky toys, and mashed potatoes. He also has a love for tater tots, although they aren't good for him or the Setsers either!

What is the cutest thing your pet does? Grizzly loves to lie on top of his dad, Dallas. He loves to have his belly and ears rubbed. Grizzly also knows how to sneeze on command.

What nicknames do you have for your pet? The Grizzinator, Mr. Quiggly, Griggaly Googaly, Grizzly Googley, Gwigley, and many more.

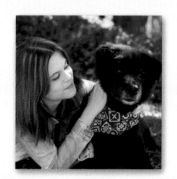

Do you dress up your pet? Yes, almost every Halloween and Christmas. Grizzly was Super Dog one Halloween and we should have had a petting booth at the church bazaar. All the kids wanted pictures with him. He also looks cool as Hawaiian Dog.

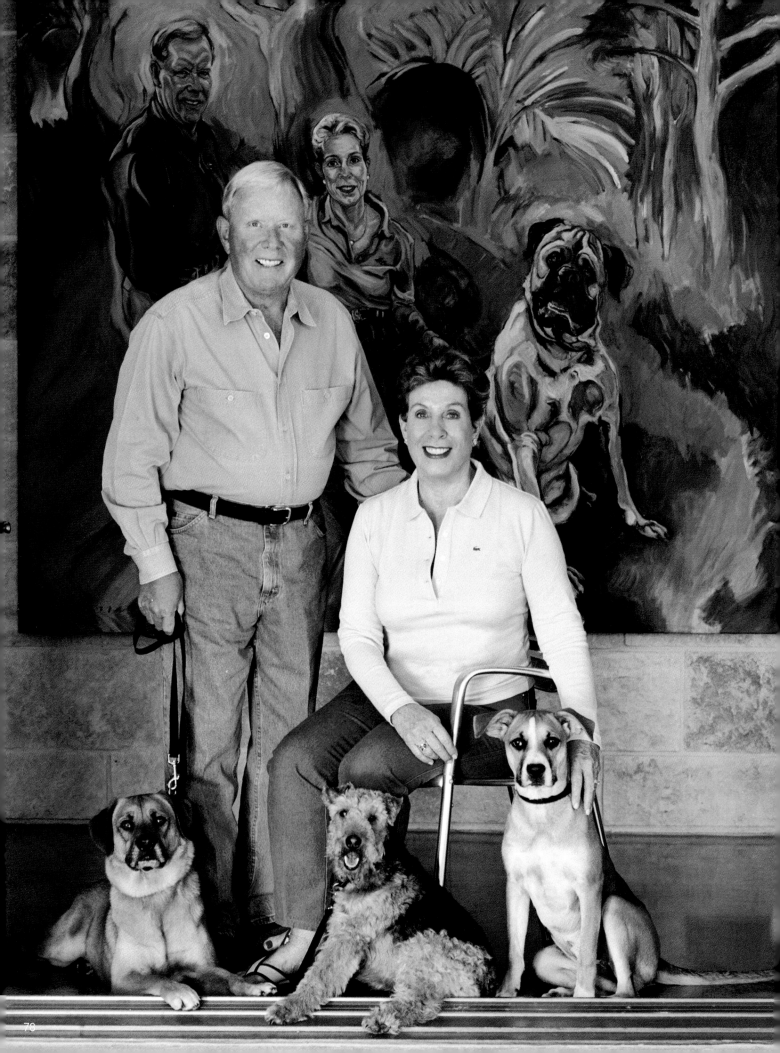

BOBBI & DICK SNYDER

Mack, Shaka, Yanni & Mija

Bobbi and Dick Snyder love the dog family they have created and cannot envision their lives complete without the joy they share with their pets.

Yanni, the Welsh Terrier, is about six years old. Yanni believes he is the king and naturally reigns the yard, watching over the landscapers and whoever dares to park in the driveway while his now best buddy, Shaka, makes certain there is no entry into the home that hasn't been authorized by his family.

Shaka, an incredibly special SPCA-adopted Rhodesian Ridgeback Mix, is known as the "warrior dog," and is about five years old. He was adopted not just for his distinctive and outstanding personality, but also to be a companion to Yanni, who had lost his best buddy, Mack. He has a strong and handsome build.

Prior to the Snyders losing their beloved Bullmastiff, Mack, to a sudden attack of bloat, they had fortunately commissioned renowned pet portrait artist, Connie Connally, to produce a portrait of Mack with them as an anniversary gift to one another as he had been their "dog and friend of a lifetime" to both of them. The painting now hangs appropriately in the family entry to the Snyders' home.

Mija is the latest addition to the Snyder household. While vacationing at their home in Los Cabos, Mexico, the Snyders were delivering food to a newly opened shelter where they saw a sick and injured puppy the shelter had accepted. The sad eyes of this Boxer and possibly Coyote-mix begged for a better life and the Snyders immediately brought Mija back to their vet in Dallas who saved her life. The word, *mija*, is a Spanish word short for *mi hija*, or *my daughter.* It is an affectionate term used by parents to describe their daughters, regardless of age.

Dick and Bobbi said their dogs have such distinct and individual personalities. Yanni is the personification of persistence and determination. Mija is all "girly" and is an amazing survivor beyond all odds. Shaka's dedication to all of us is legend. He should really be a therapy dog. It is wondrous how the other two dogs take their cues and lead from him in this regard. "'They always extend unconditional love," said Dick, "They are a comfort every day."

 Q & A

Are your pets spoiled? Definitely, famously spoiled! The house was designed and built with their pets in mind with a dedicated area complete with stained concrete floors, stainless steel cabinets and sink all secured with a built in stainless steel gate so the dogs can see who is moving about in their home.

What are some funny things your pets do? After the dogs "last run" each night, they race each other to get into their beds to be the first to receive their cookies. Mija, Yanni and Shaka chase balls together shoulder to shoulder and love water, so much that they've learned to tag team to drag motors out of the landscape water fountains!

What has touched your soul the most with your pets? Bobbi and Dick said that what touches their heart the most about the dogs is their sensitivity to her and Dick's needs and the fun and playfulness they wrap around them each day.

Almost thirty-five years ago, Rollin King and Herb Kelleher got together and decided to start a different kind of airline. They began with one simple notion: If passengers get to destinations when they want to get there, on time, at the lowest possible fares, and make darn sure they have a good time doing it, people will fly the airline. Obviously, they were right!

SOUTHWEST AIRLINES ANIMAL LUVers GROUP

& their pets ...

In keeping customers happy, Southwest Airlines also learned that in order to accommodate millions of passengers across the country, they would have to commit to their Employees a stable work environment with equal opportunity for learning and personal growth. Creativity and innovation are encouraged for improving the effectiveness of Southwest Airlines. Above all, Employees are provided the same concern, respect, and caring attitude within the organization that they are expected to share externally with every Southwest Customer.

Hence begins the story of the Southwest Airlines Animal LUVers group in March, 2003. This Employee club currently boasts more than two-hundred members and their mission is to make a positive difference in the lives of Employees' pets and the lives of others. The Group assists animal rescue groups and provides LUV, care, food, shelter, and "forever families" for homeless, furry friends.

The group has raised more than $28,000 since its inception. These funds have been obtained through silent auctions, employee donations of raffle items, and the sale of grab bags. Annually, the organization hosts four to six on-site adoptions at Southwest Airlines Headquarters in Dallas.

Animal support starts from the top of this organization, and Southwest Airlines President Colleen Barrett is definitely an animal LUVer. She supports the group's in-house efforts and many top-level executives are generous in their donations of everything from goods, airline passes and cash to fundraising efforts. An entire hallway on the second floor of Southwest's Headquarters building is dedicated to pictures of Employees and their pets.

The Animal LUVers Group often rescues starving animals from the streets and will bring them to the office to help find a home for them. A longtime Employee rescued some kittens that had been abandoned at his apartment complex in 1986, and the entire litter was eagerly adopted out by fellow Employees. One of these adoptive families is now grieving the loss of their adopted "Baby," who would have been almost twenty years old.

Many Employees feel their pets ARE their children. Occasionally, various departments have pet days when they bring their animals to the office, and many Employees get together after work to socialize with their pets. It just wouldn't be a complete family at Southwest Airlines without the Animal LUVers Group and the SPCA of Texas wishes to thank them for their continued support.

Q & A

When was the Southwest Airlines Animal LUVers Group founded? March, 2003.

What is the most unusual pet in the Group? A broad range of animals is represented in the Southwest family.

Does Southwest Airlines consider Employees' pets as part of the Southwest family? Absolutely! We have many Employees who feel their pets ARE their children. Occasionally, various departments have pet days when they bring their animals to the office, and many Employees get together in off time to socialize with their pets.

L isa Stout has a heart for rescuing animals in distress. Her pet family includes Sasha, a three-year-old Doberman-Yellow Labrador Retriever mix; Lulu, a two-year-old red mixed breed, and one-year-old Leo, a Maltese.

LISA STOUT

Sasha, Lulu & Leo

Sasha was adopted from a rescue group in Austin, Texas. Lulu was abandoned as a puppy at the family's lake retreat, and Leo joined the group from Frisco, Texas.

Said Lisa, "It's as if they know or want to repay a kindness to others. They try and compensate any family member with compassion by easing any discomfort we might experience. They bring us happiness every day."

The pets are definitely family members. Lisa says she has her five children: her two sons and three dogs. Leo sleeps in a basket beside the bed, and Lulu and Sasha curl up together on their bed in the kitchen. Bacon is prepared as a breakfast special each morning. The dogs each have their own unique toy. Sasha's favorite is Ms. Piggy, Leo's favorite is Valentine puppy, and Lulu loves her froggie toy. The dogs even have their own special attire which includes personalized Tiffany hearts!

According to Lisa, "Because Sasha was deprived nourishment as a puppy she has quite an interest in the kitchen. When I am preparing a meal, if Sasha is outside she will get my attention by licking the window until I let her inside. Lulu loves to watch television from the couch, and Leo sleeps contentedly upside down in his basket. It is quite the relaxed group in the house."

"Whenever I place a new outfit on Leo, the other two dogs undress him as if to say, 'since we can't all wear a size two, then none of us will'," Lisa said shaking her head with a smile. After having the dogs groomed, Lisa almost always returns home to find them inside the large winter planting pots (still with soil inside) on the patio. She calls them her potted puppies, and looks forward to discovering them even though they must be bathed again.

"They touch my heart because they are so sweet. They are intuitive, loving, expressive and such a part of the family," Lisa said. "Sasha watches over my two boys and is very protective. When they are swimming Sasha acts as lifeguard. She will pace around the pool and stay as close as possible to the side where they swim. She will even try to reach out and extend a paw, as if to pull them in."

"They are all so wise from their own experiences. The most important change they have made with me is modifying my type "A" personality. They have access to every room in the house and I don't care as much where the toys are scattered," laughed Lisa.

With sincere feeling Lisa said, "It warms my heart to know they are in a place where they can feel safe, and never worry about food or shelter; they are secure and loved. They are definitely more a gift to me than my gift of rescuing them. They have returned their appreciation ten-fold. There is nothing like a rescued dog. I knew the moment I looked at each of them, that they were coming home with me; that they were going to be a part of the family."

 Q & A

What do you call yourself to your pets? Mamma.

Have your pets helped you make a new circle of friends? Absolutely, because I'm involved in rescue work and the SPCA, I've met many wonderful people.

Do your pets have certain people they like and dislike? Not really. They love children.

Do you dress up your pets? Only Leo, and then not for very long!

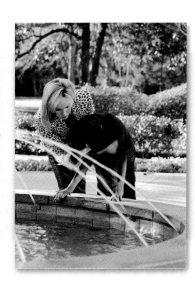

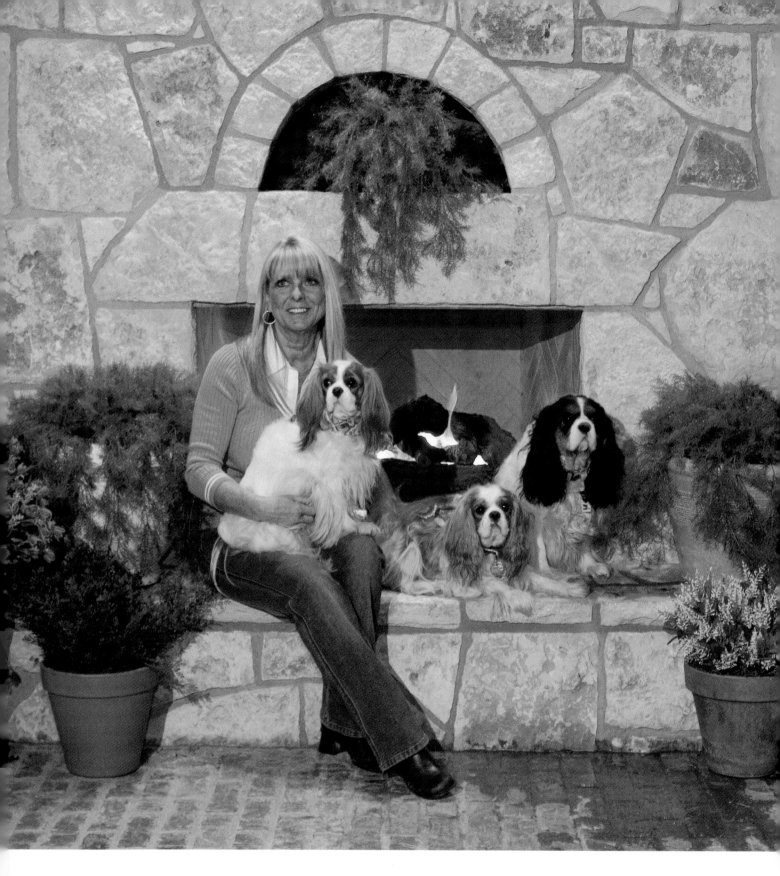

I f heaven was designed just for dogs, it would probably look a lot like Ron and Kathi Sturgeon's home.

RON & KATHI STURGEON

Madison, McKenzie & Megan

Their three-year-old Colleyville home was built with canines in mind, and that shows in every room of this 14,000-square-foot luxury French chateau. The Sturgeons share their home and their lives with three Cavalier King Charles Spaniels named Madison, McKenzie and Megan. A private dog room, with cable television and custom plumbing, has two entrances; from the outside, the dogs enter through a doggie door with a hotel-style canopy marked with its own address. Inside, the human-size Dutch door leading to the rest of the home has three arches in the bottom to allow Madison, McKenzie and Megan to peek out and watch for visitors. This house is so dog-centric that HGTV even featured it on a special program called "Pet Palaces."

"It's obvious we love dogs," Ron says. "After all, we built our house around them!"

The first indication of this passion greets visitors at the gate, where a plaque declares the home is "The Chateau for the Dogs of Our Heart." Inside, each piece of art has a dog theme, and the art medium varies from 19th and 20th century oil masterpieces to photographs, tapestries, etchings and modern art. Upon closer look, individual portraits of the dogs adorning the master bathroom are discovered to actually be hand-stitched embroidered murals from Vietnam; the house is also filled with antique clocks featuring man's best friend.
"When we decorate at Christmas, we use only ornaments that have dogs on them," Kathi says.

With doghouses and beds in almost every room, nothing is off limits to these pampered pooches, except for the home's massive two-story library and the swimming pool outside. The Sturgeons installed a child safety fence around the pool to ensure the dogs' security.
"We love them, and there's nothing that we wouldn't do for them," Ron says. That's evident by the daily dose of TLC administered by both Ron and Kathi. Kathi cooks chicken for them every day and twice a week, they get "social time" at doggie daycare. They also have their own dog walker who exercises them daily. The three dogs also are familiar sights to Sturgeons' party guests, as the costumed pups are featured on all of the party invitations sent out by the couple.

"They're by your side no matter what; they love to be with you," Kathi says. "Anything you do is good enough for them. It's that unconditional love. When you're feeling good, they love to be in your lap. They sense when I'm upset or sick and stay very close. They bring me comfort, peace and joy. I don't know what I'd do without them.

Neither does Ron, who loses his tough-as-nails business demeanor when addressing his babies.
"They bring out a silly voice from Ron that he only uses when he's talking to his dogs," Kathi says with a smile. "It's a soft side that I just love."

Q & A

What do you call yourself to your pet? Mommy and Daddy.

Do your pets have certain people they like and dislike? They like everyone.

What's the most important thing you've learned from your pets? Not to overfeed them when they're young.

Do you feel as if your pets can talk to you? They do with their eyes, or make noises when they want on the bed or for treats. They understand what you say.

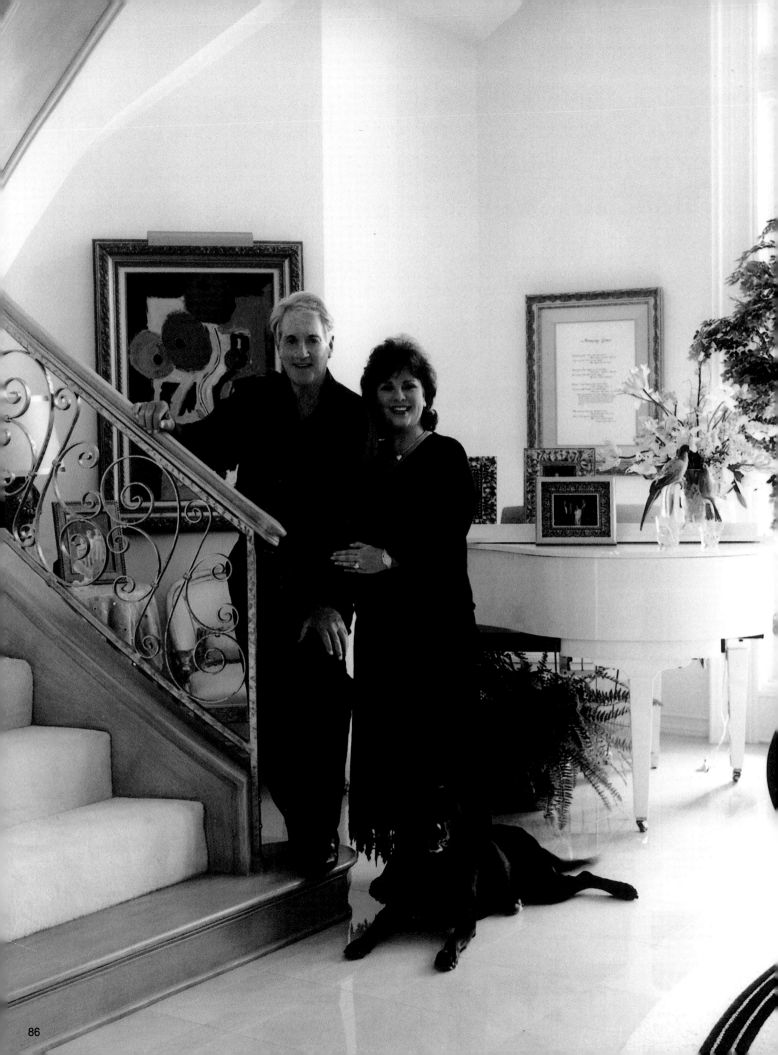

CHERI & PAT SUMMERALL

& Gracie

Amazing Grace is truly a theme for the lives of Cheri and Pat Summerall, and their Black Labrador Retriever, Gracie.

Said Cheri, "Gracie is an example of God's love for us through His love of pets. Gracie has been through us in good times and bad." Gracie was there for the Summeralls during a very serious time in their lives when Pat needed a liver transplant. Gracie was there for her Mom and Dad, in good spirits, in the midst of an uncertain time in their lives.

Pat received the liver transplant, which Gracie is glad for too. That means she now has more time to play with her Dad.

Cheri had another Labrador before Gracie named Smoke. He was the dog of a lifetime. When Smoke became ill and passed on to doggie heaven, Cheri didn't think she would ever be able to love another animal like she loved Smoke.

Cheri named a tree in their yard in remembrance of Smoke. Every day, she can watch the tree grow, and she thinks Smoke would enjoy playing under the tree. The Summeralls loved Smoke so much that they even put an in-ground pool just for the dog to play in. Smoke loved the pool but Gracie doesn't care for it too much, as she would prefer to play with the grandkids.

One day, a while after Smoke was gone, Pat suggested they look at a little puppy. Gracie asked Cheri and Pat to take her home. She promised to be good.

Gracie is a very well-behaved dog and loves to talk to strangers. She wears beautiful dog collars that accentuate her dark, shiny coat. She likes to take the collars off and play with them sometimes too. She is about four years old but has wisdom and love beyond her years.

Q & A

Does your pet comfort you? Yes, Gracie has been there for us for better and for worse.

What is the cutest thing about your pet? Gracie loves to go to doggie day care. She gets so excited when she knows she is going. When she comes home, she will be exhausted but very happy.

What touches your heart the most about your pet? Gracie loves everyone unconditionally, just like God loves us. She brings a lot of joy to our lives.

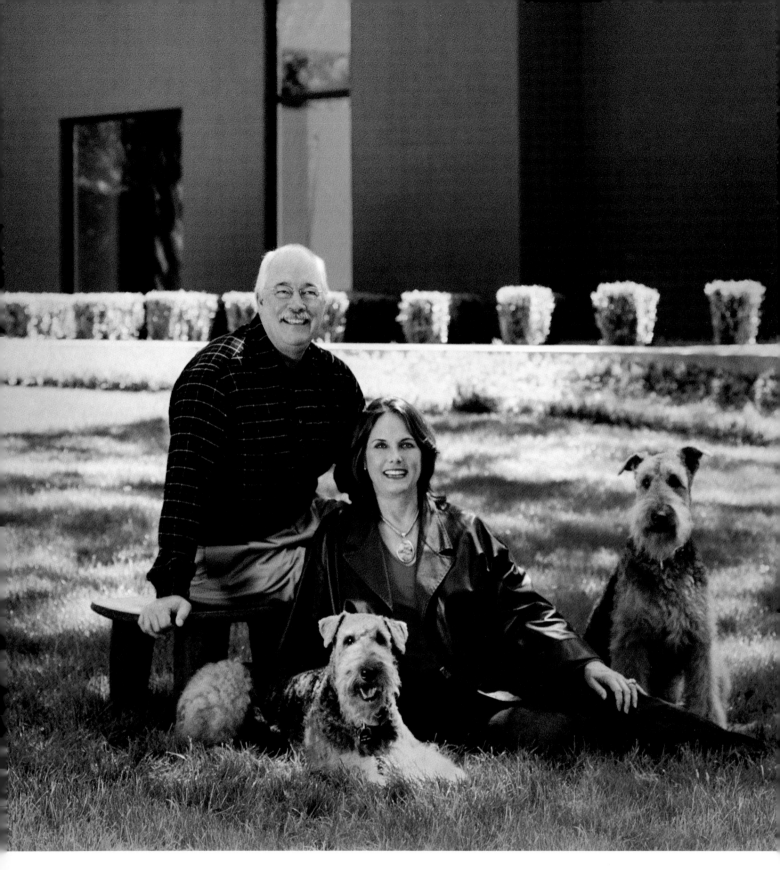

David and Ann Sutherland have always been fans of large breed dogs. Over the years, David has had Labrador Retrievers and a few Lab mixes that were special companions. Ann has had Airedale Terriers in recognition of her allergies to fur since Airedales have hair instead of fur, very much like Poodles. Once their "separate" dogs passed away, David and Ann agreed that two more large friends were on the agenda. David expected to have a Lab and Ann opted for another Airedale.

DAVID &
ANN SUTHERLAND

Lulu & Lucque

While "just looking" at a litter of Airedales, little Lulu pawed at Ann and Lucque, her brother, danced around David's feet and was coy from the outset. Thinking Ann would select one of the two, David quickly identified the little male as his. All Ann could say was that Lulu was her choice but she really wanted all NINE of the puppies.

Most people are not familiar with Airedale Terriers. They are the largest of the Terrier breeds and antique art records the existence of English dogs that resemble the Airedale Terriers of today. Historically, Airedale Terriers were used to hunt wild animals and were among the first to be used by police in Europe. True to their heritage, Lulu and Lucque are also devoted litter mates and have very sweet and loyal dispositions.

According to David, "The dogs are pretty tuned in to us and pick up on our emotions." When Ann is out of town, they mope. When she comes home from a trip, they are overjoyed. Ann and David agree that Lucque and Lulu are the sweetest friends and the most wonderful companions.

Ann is the one most in charge of spoiling them. They have full run of the house and particularly enjoy the cashmere covering on the living room sofa! They go to work with Ann each day at her fabric company, Perennials. Special treats include scrambled eggs on Sunday and home-cooked rice and chicken on a daily basis.

Lucque and Lulu are bathed frequently in the walk-in shower at the Sutherland's home and enjoy regular grooming, with bandana rewards, to help keep their skin and hair in top condition. Lulu is a cuddler and loves being in the bed with Ann and David and Lucque protects everyone from his Perennial's pillow perch on the floor.

While David and Ann have six children and ten grandchildren between them, the kids have often said they would like to be reincarnated as one of Ann and David's furry companions. As for David's former preference for Labradors, he is eager to say that Lucque and Lulu are the "best Labs" he has ever had.

Q & A

Are your pets compassionate? Lucque is the boss except when he can't see Lulu. If she is out of his sight he has been known to wail. It's possible she even enjoys teasing him from time to time. When one of the dogs is sick, the other one seems to be genuinely concerned. Both dogs are very sensitive and a raised voice will only inspire them to chime in at decidedly higher decibels. While Lulu is a pragmatist, Lucque is soft spirited and quite the romantic.

Are your pets considered part of the family? Yes, we are their thankful custodians and companions.

What is the cutest thing your pets do? When the dogs take a shower, the first one goes in, while the other waits to pounce when he or she emerges. The dogs love long walks. Lucque loves to watch TV, especially the Nature Channel, and he barks when there are potential friends he hasn't met on the screen. Lulu doesn't watch TV.

arol Swanda is a champion for the betterment of all animals; she loves those that nobody else will. She feels her pets have given her life new meaning and purpose. She feels it is her privilege to provide love, shelter, and safety to pets that are deemed "hopeless" by others.

CAROL SWANDA

Callie, Nick, Holmes Cammie & Brandy Mae

Initially, Carol really wasn't interested in having a pet since she had a legal career that took up all her time. There came a point, however, when Carol discovered her life was in a downward spiral. When someone suggested that a pet might fill the void in her heart, Carol decided to give it a try.

Carol adopted Brandy Mae, a Cocker Spaniel, who turned out to be the dog of a lifetime. Sadly, Brandy Mae passed away in 1998.

Carol said, "Brandy Mae helped redeem my broken heart. She showed me unconditional love. Now, I help to redeem the lives of other critters that have been abandoned, orphaned or relinquished. It is an honor to do for them what Brandy Mae did for me."

Carol's pet family currently consists of several beloved animals.

Cammie, a fourteen-year-old cat, was a special friend to Brandy Mae. Cammie was a diseased, malnourished stray who appeared at Carol's office one day, jumped into her car, and snuggled up to Brandy Mae. The rest is history.

Nick is a Humane Society Dalmatian/Border Collie mix. Said Carol, "Nick is a smart, very high-energy boy who came to me with a lot of anxiety and insecurity. He's been the most challenging of my animals, and there were times when I would get exasperated with him. When he would look at me with eyes full of desperate adoration, I just couldn't give up on him! I'm a stronger person and a better dog owner because of him and he's doing really well now."

Holmes, a Cocker Spaniel, is a very special, older dog. When he was eleven years old, Holmes's owners were killed in a car accident and he was left homeless at a kennel, facing possible destruction. "My dog trainer called and described the situation and I just couldn't say no," Carol explained. "Holmes was such a loving dog. He deserved a good life. He is loyal and sedate, but also loving and cuddly. He's my teddy bear!"

Callie, age five, is a Humane Society adopted Siberian Husky who had been at the facility for several months. Carol couldn't stand the thought of Callie being euthanized just because others didn't want a big dog that sheds. She decided Callie would make a nice addition to the Swanda household. "Callie has a determined, confident spirit that inspires me," Carol said. "She is independent, regal, affectionate, and in control of every situation."

Carol and her pets are pleased to be part of the *Texans and Their Pets* project. The Swandas' stories are sure to leave an impression on other pet owners. They are proof that love brings hope to every situation and enables one to overcome many difficult circumstances.

Q & A

Would you say your pets are spoiled? Okay, I have to admit it: Most of my pets believe they are entitled to all the comforts and privileges to which they are exposed.

What are some cute things your pets do? Nick does a headstand in the corner of the couch, sticks his back legs up in the air, and moves them around like he is pedaling a bicycle. He's just goofy! He can also open doors, unlatch gates and scale walls. So, to keep him in the backyard, we had to build a fence that reaches up to the awning of the roof on our house. Holmes also does a bunny hop when he is excited. It's so cute!

What touches your heart the most about your pets? The way they love me, their devotion, dependency and trust. Each has suffered setbacks in life. Yet, all of them have been willing to start over and create a new life with a total stranger. They have taught me how to live and not just survive.

JANINE TURNER

Cream Puff, Chubbs, Sparkle & Maggie

Janine Turner, renowned actress, mother, animal lover, and Texan at heart, has had several pets over the years, but none are as special as the ones she and her daughter, Juliette, have now.

The Turners current brood of pets includes Cream Puff, a white Poodle who loves to sleep on top of people, and Chubbs, a celebrity Yellow Labrador Retriever, who was featured in one of Janine's movies and a television commercial.

Janine and Juliette also enjoy the company of four horses. One horse, Maggie, is a beautiful Palomino Quarter Horse named after Janine's character in the *Northern Exposure* television series. Maggie has her own private barn, complete with windows, large doors, fans and 12' x 24' stalls. Like most movie stars, Maggie follows a special diet. It consists of oats with vitamins and lots of water.

Janine's daughter, Juliette, and Cream Puff the Poodle, often enjoy having a tea party with tea and biscuits. Cream Puff enjoys being chauffeured around by Juliette in a baby buggy.

Janine and Juliette will often rescue stray cats. One cat, Sparkle, is very glamorous and has markings that make him look like he is wearing a black-and-white tuxedo.

Additionally, Janine has thirty Longhorn cattle as pets, two birds, and three rescue dogs named Jessie, Buster and General.

Just like the SPCA of Texas, Janine believes it is everyone's duty to value their pet's companionship and to honor the responsibility of caring for them. The most important thing she has learned from her pets is that they are very healing, through the good times or bad, happy or sad. Janine said, "Their devotion and love is consistent."

Q & A

What is the cutest thing your pets do? My cat, Sparkle, and I have meow conversations. My Yellow Lab, Chubbs, plays tag with Juliette, and my rescue Lab, General, sings.

What touches your heart the most about your pets? Their devotion and unconditional love. It is our duty to treat them as gently and humanely as we can.

What is the best thing about your pets? They are always happy and joyous when we walk in the door.

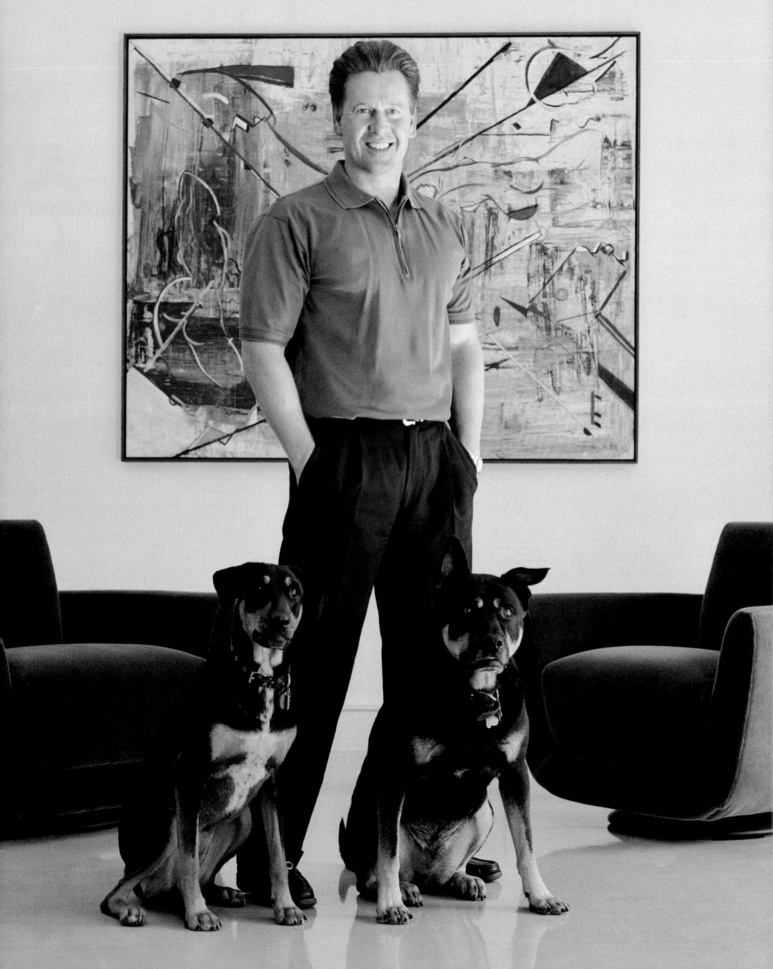

ARNIE VERBEEK

Enzo & Milla

Arnie Verbeek loves animals of all kinds, especially the two "purebred" pups he acquired from the SPCA of Texas.

Arnie is the proud owner of six-year-old Enzo, a devoted Rottweiler/Akita mix and Milla, a Doberman mix who is sweet and playful at three years young.

A natural born retriever, Milla enjoys fetching items around the house to entice others to play with her. Her main job is to get the newspaper every morning and she insists on being involved in every soccer game as well. In addition to "supervising" Milla's paper route, Enzo enjoys keeping the yard safe from squirrels and performing a number of tricks that Arnie has taught him over the years including high fives, playing dead and pretending to take a bullet.

The dogs are loyal, loving, happy companions. Arnie smiled, "We make lots of friends when we go for walks." Both dogs look forward to socializing at the Katy Trail, Starbucks, Petsmart, the occasional 5-K walk as well as frequent visits to the office where they romp with Arnie's employer's three dogs on a golf green adjacent to the building.

The Verbeek house was definitely built to accommodate a big dog-friendly lifestyle. The dogs enjoy their own indoor dog room, a stainless steel, plaster, tile and concrete room that is "indestructible" to their sometimes rough play, yet still part of the main house and can be hosed out if muddy. Arnie said, "We put exit benches in the pool for them and an exterior shower with hot water for baths as well as a dog trail along the perimeter to protect the landscaping from their squirrel patrolling."

Arnie continued, "Our dogs are very affectionate and devoted to us. They are great at reading our emotions and provide so much comfort and joy. They want to be included in all of our activities even if it just snuggling on the couch watching television. The most important thing I've learned from my pets is that patience goes a long way. I love to train my dogs. I think it is important that they are well-behaved. We are a very balanced family; we have bonded with the dogs and the respect goes both ways. There is a special link between us all."

Q & A

Have your pets touched your soul/inner being? Yes, continuously throughout my life. I grew up with all kinds of pets, literally on a petting farm in Vught, the Netherlands. Pets bring balance to my life. Every second there is life and love in our house. I could not imagine sharing my home without my animals.

What are the dogs' favorite treats? The dogs enjoy doggie bagels, carrots and healthy chew treats. Their favorite toys are tennis balls and stuffed animals that they carry around throughout the house

What is the cutest thing your pets do? They make me laugh every day; Milla's complete obsession with balls and the way that Enzo tosses his paws when he walks.

Would you consider your dogs compassionate? Very! Dogs are very welcoming. They know when you are sad or happy and understand our feelings and provide a very calming presence.

Charlie may be small in stature, but this talented and energetic mixed terrier has his own oversized luxury SUV even if he can't personally drive it. His Mom, RE/MAX Realtor Mauri Way, will quickly let you know her world revolves around Charlie, her only child. He recently made the cover of a Kentucky magazine, *PawPrint*, debuted his acting skills in a North Carolina dog play, plus he graces the front of all Mauri's holiday and note cards.

Mauri Way

& Charlie

Charlie is a very lucky and special little dog. Mauri found Charlie on PetFinder.com and rescued him from a local pound where he was scheduled for the unthinkable. He was a terrified, thin, thirteen-pound dog with chewed off hair, fleas and severe kennel cough. When Mauri saw him it was love at first sight! Mauri named him Charlie because of his coloring and his paws point out like Charlie Chaplin. Coincidently, it was Chaplin's birthday.

Charlie is so funny, incredibly smart and the most affectionate dog I've ever had," smiled Mauri. He sleeps on the pillows next to Mauri and they always wake up snuggled nose to nose. Mauri takes Charlie to the playground almost every evening to run around and practice new tricks plus they take lots of cross country road trips, mostly to doggie camps. The days are packed full of agility, obedience, games and even canine acting! The evenings are luxurious pet friendly resorts with room service, pet massages and bubble baths of course. Charlie loves to dress up as Santa and visit nursing homes too.

Traveling with Charlie has resulted in quite a circle of interesting friends so Charlie has his own email address now. Up-coming road trips include Santa Fe, Jackson Hole and Sun Valley for starters. These long road trips require Charlie to travel in style and comfort so the SUV was custom equipped with screens in the headrests so Charlie can watch his favorite DVDs at eye level from his booster seats. His favorites are *Seabiscuit* and *The Horse Whisperer*.

Charlie goes almost everywhere with Mauri even some R/E closings. In fact, while out shopping Charlie was "discovered" by an Animal Actor Agent so you'll see more of Charlie. He does not make enough for Mauri to retire so Charlie donates his earnings to animal charities in hopes all homeless pets will get as lucky as Charlie. Mauri donates a portion of her proceeds from each real estate transaction to medical research and welfare of animals. She recently co-sponsored a heart research grant at Texas A&M through Morris Animal Foundation in memory of her Norfolk Terrier, Bailey. Mauri also patented a pet product she hopes to market with proceeds going to charity as well.

"Charlie is perfect! He lets me control the remote, he never leaves the toilet seat up, he lets me buy anything I want, he always makes me smile, and he's the very best snuggler!" laughed Mauri.

Then in a more serious tone, Mauri states, "Rescuing a pet is an incredibly heart warming and gratifying experience. I was very fortunate that Charlie's sprit was never broken. He calms my soul and makes me take time to relax and enjoy my own surroundings. Charlie brought love and magic back into my life. He has made me realize no matter how busy I am or how much I have to do; I can take one look at him and decide it can wait until later. Sometimes I don't know who rescued whom."

Q & A

Would you say your pet is spoiled? Beyond rotten. I want to come back as my pet!

How often do you buy your pet something? Probably three to four times a week, especially from *Fido Friendly Travel* and *Animal Fair* magazine ads.

Does your pet have people he dislikes? No, Charlie loves everyone! He's very social.

What makes you laugh the most about your pet? When he flies in and out the doggie door with toys and when he yawns; he makes the funniest yawning sounds just like a human. He does something else funny but I don't dare put that one in writing! He knows about eight good tricks too. He cracks me up!

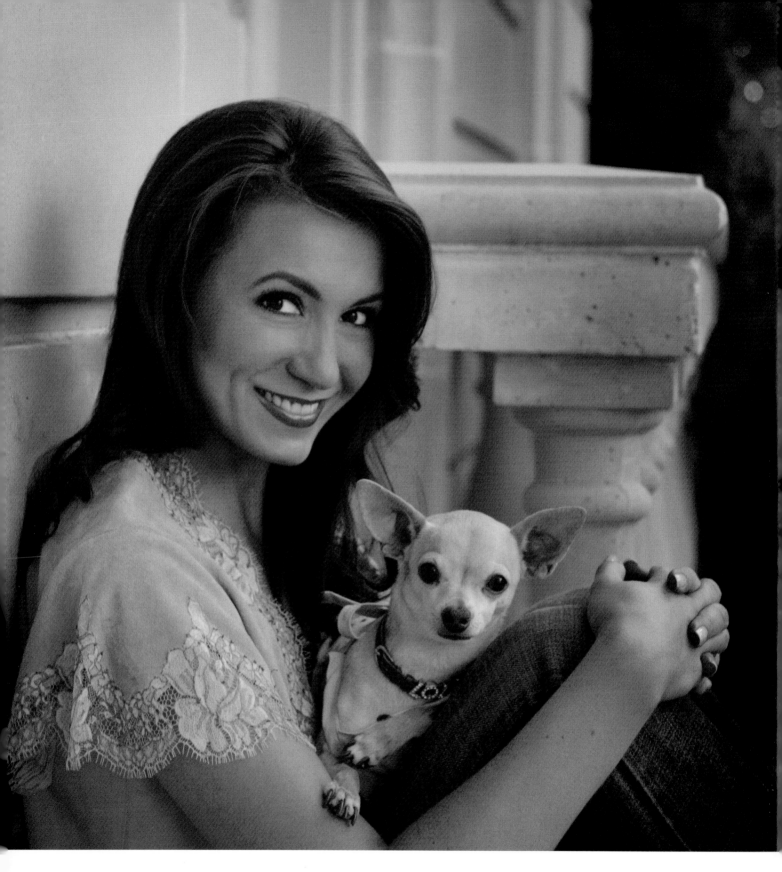

When Kimberly Schlegel Whitman was a senior at Southern Methodist University, she decided she needed the companionship of a four-legged friend. Lola, a beautiful fawn-colored apple head Chihuahua, soon found her way in to Kimberly's life and the girls have been partying away ever since.

KIMBERLY SCHLEGEL WHITMAN

& Lola

This accomplished author, businesswoman, newlywed, philanthropist, daughter and friend had time to record her travels and events with Lola in her first coffee-table book, *The Pleasure of Your Company*, published in fall 2004.

The project was a natural extension of her professional life, as Kimberly is the owner of R.S.V.P. Soiree, an upscale special event rental and custom invitation company in North Texas.

Kimberly's second coffee-table book, *Dog Parties*, will make its debut in fall 2006. Kimberly said, "Lola is such an inspiration for all my work. She is a source of creative input. Some of her great events include Howl-oween parties, Garden parties, Graduation from Dog Training parties, and of course the requisite Birthday parties. Lola sits on my lap as I am working at my desk which makes every day a brighter one."

Always thinking of other pet guests, Lola prefers edible party treats and her favorite hors d'oeuvres include Greenies and carob and peanut butter-covered popcorn from Just Dogs Gourmet Bakery and Blind Dog Catering. Lola and Kimberly always offer their four-legged guests a huge variety of treats and Lola is famous among her friends for her party treat buffet. She even offers a variety of flavored water, from lemon water to toilet water!

Lola is Kimberly's ultimate shopping companion and world traveler. They were both featured on the Style Network's *Whose Wedding is it Anyway?* During that time, Lola achieved "celebrity pet status" with an airline and gets to fly in her own seat! The pair love to travel together and Lola prefers the beach scene and fashionable cities like New York, Los Angeles and Dallas.

Lola is also a fan of doggie couture and sports her own bikinis, life preserver and her own closet in the house. Kimberly said, "We have the same taste in clothes! We often dress alike without even planning it!" Lola frequently enjoys pawdicures (dog manicures) from Kimberly's K9 Dog Spa and her favorite paw-lish color is pink.

When Kimberly recently married, Lola came to a Western-themed wedding brunch dressed appropriately for the occasion in a Cowboy hat and fresh daisy collar. Lola is a great judge of character and when she took an immediate liking to Justin Whitman, Kimberly knew that he was "the one."

When asked if her pet has touched her inner soul, Kimberly said, "I am the person that I am today partly because of Lola. She treats others with such great affection and is a source of comfort and joy to everyone she meets."

Q & A

Would you say your pet is spoiled? More than spoiled! She rules the house! Whatever Lola wants … Lola gets!

Do you dress up your pet? All the time! Lola is always dressed for the occasion! She has her own closet in the house which is filled with outfits for every occasion. She has day dresses, party dresses, skirts, hats, costumes, bath robes, bathing suits, tee-shirts, sweatshirts, sweaters, fur coats, and she recently got her first pair of jeans! She also keeps her nails looking nice with regular pawdicures (pet pedicures) in her signature pink polish.

Where does your pet sleep? We have beautiful dog beds in each room of the house except the dining area for her naps but she spends the night under the covers of our bed.

Does your pet talk with you? Lola has never had trouble communicating what she wants!

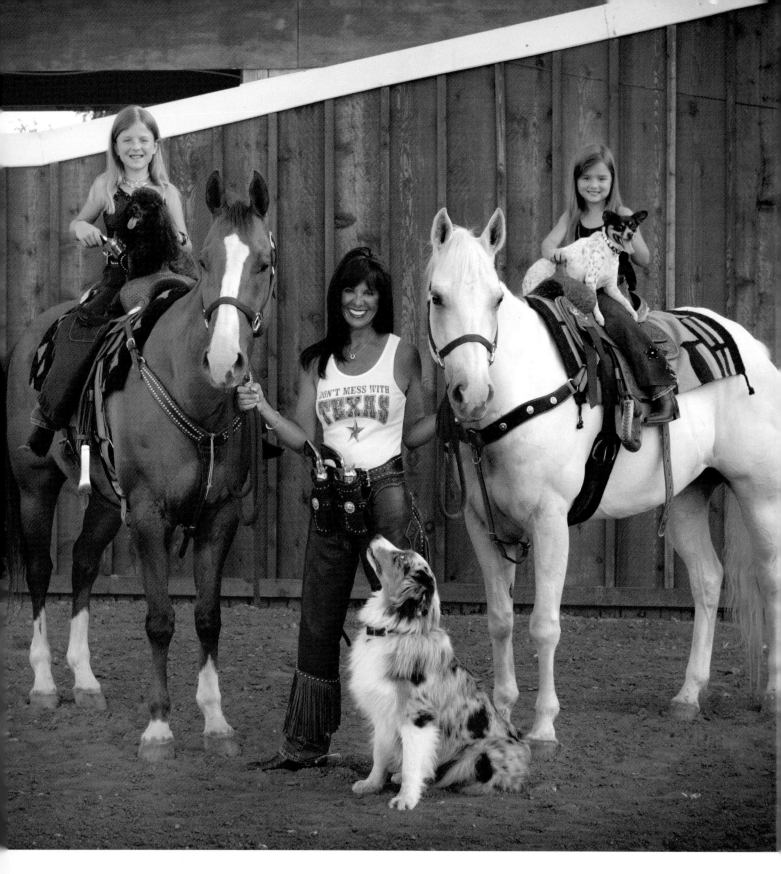

T he Williams family definitely loves pets and they have the variety to show for it! Sigrid, Brian, Grace and
Lila aren't complete without a few furry hugs every day.

SIGRID, BRIAN GRACE & LILA WILLIAMS

Bridget, Dixie, Cowboy, Stripes, Snowhite, Buster, Dundee, Snowball & Roadkill

Their diverse group includes three dogs, four cats, three horses and three turtles. Bridget is a four-year-old Poodle who loves to work cows in the arena and Dixie is a two-year-old Rat Terrier. New to the family is Cowboy, an Australian Shepherd who is Canadian. The cats include a tabby named Stripes, the "little white tramp" also known as Snowhite, and a Ragdoll named Buster. The newest family member is Roadkill, an orange tabby found on the side of the road. The Williams also have three horses stabled approximately forty miles from Dallas named Dundee, Snowball and Cowboy.

Are these pets spoiled? "Totally," laughed Sigrid, "The animals' needs are met first before the people's needs. They go wherever they want to and sleep wherever they want. We move around them, instead of them moving around us. At night, the dogs and cats sleep with us, except for Stripes. Our furry crew gets along beautifully. The dogs and cats take care of each other and even lick and clean each others' ears."

The Williams' pets bring smiles and laughter as well. Dixie is the serious one who observes everything and protects the property. Sigrid is lucky enough to have her own personal pet navigator when she drives about town. Bridget rides on the console and sometimes turns around backwards, which brings a round of laughter from the passengers. They all wonder where she is going. Cowboy will not take a drink without first stomping in his water bowl and making a mess. When Sigrid takes a bath, Buster likes to sit on the side, as well as drink water from the faucet. When it snows, as it rarely does in Dallas, Bridget and Dixie become young frolicking pups again and love to be outside.

When asked what touches her heart the most about her pets, Sigrid said, "We communicate easily; they direct you and let you know what they need. They look at you inquisitively when something is amiss, and they know when everything is all right. Whenever one of us is sick or crying, they are gentle and stay close. They're very in-tune with everyone in the house."

Sigrid continued, "When I want to be quiet without anyone or any interruptions, I always want one of the animals, usually Dixie or one of the kitties. They take so little and give back all the time. All they want to do is give. Even the horses want to work for, and please us. It's wonderful to know what a good home we provide for our pets; what a great quality of life, and what we share with the rescued animals. The pets have taught me to be gentler; how to listen closely, and the art of patience. They have taught the kids responsibility, that there is more to having pets; they have to take care of them."

Q & A

What do you call yourself to your pets? Grace calls herself Mom and refers to Brian and I as the grandparents. Lila is little sister.

Do your pets have certain people they like and dislike? Not really. Dixie is a little tentative until she gets to know you because she's the protector. The cats are indifferent.

Do you dress up your pets? Grace and Lila like to dress up Dixie and Bridget. Bridget takes it the best and they can do anything to her.

How often do you buy your pets something? At least once a week.

101

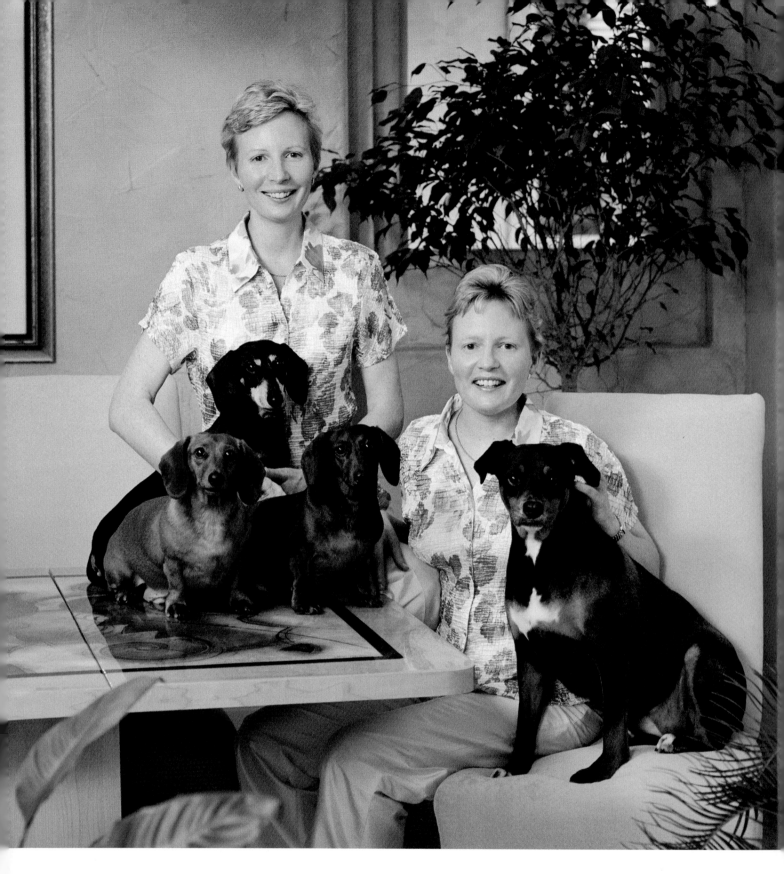

Not everyone can say their dogs are bilingual, but twin sisters Michelle and Nicole Yost have four dogs who understand the languages of German and English (perhaps because the breeds come from German heritage!)

MICHELLE & NICOLE YOST

PJ, Oscar, Ethan & Maggie

The Yosts have three Dachshunds and a Dachshund "wanna-be".

PJ, short for "Pride and Joy," is a thirteen-year-old black and brown Dachshund who is matriarch of the pack. Oscar is an eight-year-old red Dachshund who mostly burrows in a blanket and sleeps with his toys. Brindle-colored Ethan, a seven-year-old Dachshund who had been starved and abused, was adopted from the SPCA. Last but not least, there is four-year-old Maggie, who looks like a miniature Rottweiler that they found on the side of the road. Maggie hit the jackpot, not only was she starved, but she also had distemper. Her two angel good Samaritans, with the help of a veterinarian, pulled her through a viral infection that is usually fatal.

Said Nicole, "Saying our pets are spoiled is an understatement. Some sleep in our beds, they get treats and scraps from the table, car rides—we even heat up their blankets in the dryer for them to sleep on in the winter! Every time we go to the grocery, we have to get them something. Friends say they want to come back as our dogs. They are our children and our mother considers them the four grandchildren."

Nicole continued, "While we watch television, Maggie will walk on top of the back of the couch and come paw us on the head to get our attention. When the phone rings, the dogs act out and begin barking because they know we want them to be quiet, so we'll give them a treat and then they'll be quiet. They have us all figured out!"

Michelle added, "Ethan used to catch snakes, birds, lizards and things and bring them into the house as gifts. Everyone thinks Ethan is a true gentleman, but we know better; he is a hoarder!"

All of the dogs are very compassionate and surround Michelle and Nicole if they are sick. The two rescued pets are very sensitive and quickly pick up on a change in emotions. They said having the dogs has enhanced their friendships with other people. They have made many acquaintances from their daily walks with the dogs because people slow down, smile, and sometimes stop to talk.

"Every day they bring us such joy. Just watching them play makes us laugh. They are always in a good mood, always playful and follow us wherever we go. When you look at what the two rescued dogs have been through, they are such survivors, so gentle and sweet," said Nicole. Michelle agreed and said, "They are content with the little things in life, and provide a lot of unconditional love."

 Q & A

Would you call your pets compassionate? Yes, very!

Do your pets have certain people they dislike? Because they are not around children very much, the three Dachshunds don't like kids too much, but Maggie does and will let them pet her.

Do you dress up your pets? No.

Where will your next pets come from? The two rescue dogs are much more loyal. We believe they know where they came from and how good they have it now. From now on, any future four-legged children will come from the SPCA.

PANACHE
TEAM MEMBERS & their pets...

Front Row: Emily Kattan (*Graphic Designer*), Suade Cunningham-Scott with her mother, Michele Cunningham-Scott (*Art Director*) and Brownie Chocolate Muskateer, Beth Gionta (*Editor*) and Zoë, Luanne Honea (*Production Coordinator*) and Sir Kalen "Gilby."
Back Row: Carol Kendall (*Project Manager*), Kristy Randall (*Production Coordinator*) and Pepper, and Mary Acree (*Graphic Designer*).

Lynn Townsend Dealey '05